Turn of the
Century Home

The Renaissance Society at The University of Chicago

January 16 – February 27, 1994

William Daniel Allen
John Banks
Thomas Beeby
Darcy Bonner
Lawrence Booth
Stuart Cohen
Susan Conger-Austin
Gwendolyn Conners
Howard Decker
Dirk Denison
Garret Eakin
John Eifler
Douglas Farr
Patrick Fitzgerald
Paul Froncek
Douglas Garofalo
Julie Hacker
Philip Hamp
Laura Hochuli
David Hovey
Karen Johnson
Phillip Craig Johnson
Ronald Krueck
Roy Kruse
Peter Landon
Tannys Langdon
Frank Christopher Lee
Dirk Lohan
Michael Lustig
James Mastro
Margaret McCurry
James Nagle
Michael Pado
George Pappageorge
Frederick Phillips
Kathryn Quinn
Christopher Rudolph
Ken Schroeder
Linda Searl
Claudia Skylar
David Swan
Stanley Tigerman
Joseph Valerio
Wilmont Vickrey
John Vinci
Cynthia Weese
Catherine Wetzel
Daniel Wheeler
Fred Wilson
Nabil Zahrah

Acknowledgments
Susanne Ghez

The history of architecture is nothing short of a history of human needs. Home, office, factory, school, shopping center, temple: of the places built to accommodate the range of human needs and activities, home is the structure which reflects this history of needs the most immediately. *Turn of the Century Home*, a survey of single-family home designs by 48 Chicago area architects, asks what constitutes home at the end of the 20th century.

I feel fortunate in that Frank Lloyd Wright's Robie House is located two blocks from The Society. Encountering this wonderful home on a regular basis over the last twenty years has afforded me the opportunity to reflect on Wright's achievements at bringing the home of the nineteenth century into the twentieth. While no one would doubt that the birth of the modern metropolis represents a genuine architectural revolution, one could still ask if the same sort of revolution has occurred within the field of domestic architecture. Much has happened since Wright's alterations of and appendages to the vocabulary of the Victorian home. The home, however, will always be subservient to our most basic needs regardless of change. There, of course, is no formula nor causal progression which on a consistent basis links changes in our needs with changes in architectural practices. But perhaps modernity's dust is beginning to settle just enough so that we can we can glean from the contemporary home if and where there have been changes in our needs and how those needs, changed or unchanged, are being accommodated within contemporary dwellings. With an emphasis away from revolutions in building practices, *Turn of the Century Home*, invites the home to be read as that which it always has been, a map of our living patterns as structured by our needs.

As with any undertaking of this nature, *Turn of the Century Home*, has its genesis in several sources least of which is Chicago's history as a center of innovations in modern and post-

modern architecture. Chicago is home to some of the foremost architects in the world with whom I have had the pleasure of working during this exhibition. I am particularly indebted to friend and architect John Vinci. The exhibition grew out of discussions with John over several years. We were curious to compare recent single-family dwellings with the great houses built at the turn of the last century. I am grateful to John for providing us with wonderful images of some dozen houses which he incorporated into the installation design, including the Glessner House, the Charnley House, the Madelener House, and the Robie house.

It was my great privilege to do studio visits with each and every architect. The ideas discussed, the projects considered, the possibilities dreamed, and the insights gained linger pleasurably. Their input and enthusiasm for this project seemed to know no bounds. The questions raised by this exhibition extend well beyond the scope of this survey and I am extremely grateful to the Graham Foundation for Advanced Studies in the Fine Arts for awarding The Society a generous grant in support of the project and for hosting the informative lecture series which kept the dialogue grounded in a complex set of issues. I would also like to thank Akiko Busch for her thoughtful lecture and insightful contribution to this publication.

Others I would like to acknowledge for their assistance with this publication include Jason Pickleman and Leslie Bodenstein of JNL Graphic Design, Jean Fulton and Joe Scanlan for editorial assistance, and Tom van Eynde for photographing the installation and the architectural models. At The Renaissance Society thanks are extended to Randolph Alexander, Director of Development, Hamza Walker, Director of Education, Karen Reimer, Preparator and Registrar, Patricia Scott, Bookkeeper and Secretary and Louis Brandt, Farida Doctor, and Lisa Meyerowitz, our Work-Study Assistants.

Turn of the Century Home and the accompanying lecture series were made possible by the Illinois Arts Council, a state agency; the CityArts Program of the Chicago Department of Cultural Affairs, a municipal agency; the Andy Warhol Foundation for the Visual Arts; The Graham Foundation for Advanced Studies in the Fine Arts, Chicago; The John D. and Catherine T. MacArthur Foundation; The Sara Lee Foundation; Refco, Inc.; The First National Bank of Chicago; VOA Associates Incorporated and our membership. Indirect support has been received from the Institute of Museum Services, a federal agency offering general operating support to the nation's museums.

This publication was also made possible by individual contributions from Banks/Eakin Architects; Booth/Hansen & Associates, Ltd.; Stuart Cohen & Julie Hacker, Architects; Susan Conger-Austin, Architect; Roy H. Kruse & Associates, Ltd.; Lohan Associates; Nagle, Hartray & Associates, Ltd.; Optima, Inc.; Michael J. Pado AIA Architect; Pappageorge Haymes, Ltd.; Kathryn Quinn Architects; Schroeder, Murchie, Laya Associates, Ltd.; Searl & Associates, P.C. Architects; Mastro & Skylar Architects; Valerio Associates; John Vinci; Wheeler Kearns Architects, Inc.

Finally, I would like to acknowledge all of the participating architects without whose work we would literally be out in the dark.

Susanne Ghez
Director

Exhibition List

William Daniel Allen
Shields Vacation House, 1990-91
Brevort, Michigan
Plans, elevations, and rendering:
24 x 48 inches each (framed)

John Banks and Gerrit Eakin
Fogel Residence, 1991
Plan: 13 x 13 inches
Rendering: 27 x 27 inches (framed)

Racine Residence, 1993
Model: 18 x 27 inch base
Plans: 14 x 14 inches

Thomas H. Beeby
Old Quarry Residence, 1993
Forty-two computer-generated
drawings: 8 1/2 x 11 inches each

Darcy Bonner
Himmel/Bonner Architects
Eagle Residence, 1986
Model: 23 x 21 1/2 inch base
Three plans, two elevations and
five renderings: 11 x 17 inches each

Laurence Booth
Five Easy Pieces, 1994
Model: 33 5/8 x 40 3/8 inch base
Collage drawing:
30 x 20 inches (framed)

The House That Can Take It, 1994
Lakeside, Michigan
Model: 25 x 25 inch base
Collage drawings: 30 x 20 inches each (framed)

Stuart Cohen and Julie Hacker
Highland Park Residence, 1993-94
Model: 24 x 28 1/2 inch base
Plan: 20 x 30 inches (unframed)

Grand Beach, Michigan Residences, 1993-94
Model: 20 1/2 x 29 1/2 inch base
Plan: 18 x 20 inches

Susan Conger-Austin
Conger-Austin Residence, 1989
Model (built by Susan O'Conell):
25 1/2 x 6 inch base
Plan: 14 x 20 inches

Howard Decker
DLK
Architecture, Landscaping, Planning
Secrist Estate, 1994-95
Model: 9 1/2 x 12 1/4 inch base
Two renderings: 40 x 30 inches (framed)

Lot 12, New Buffalo,
Michigan, 1994-95
Model: 9 1/2 x 12 inch base
Two renderings: 40 x 30 inches (framed)

Dirk Denison
Peterson II Residence, 1993
Model: 20 x 30 inch base
Rendering: 21 x 33 1/2 inches

Washington Residence, 1993
Model: 10 x 25 inch base
Two plans, two elevations:
10 x 25 inches each

John Eifler
Eifler & Associates
Wisconsin Residence, 1992-93
Model: 31 x 21 inch base
Plan, elevations, renderings: 24 x 36 each
(framed)

Doug Farr and Gwendolyn Conners
Ruff House, 1990
Model: 4 x 20 3/8 inch base
Plan and two renderings: 14 x 18 inches each

Pat Fitzgerald
Fitzgerald & Associates
Centennial Court at Central Station, 1994
Drawing: 24 1/4 x 36 inches

The Prairie Homes of Dearborn Park, 1994
Drawing: 24 1/4 x 36 inches

5 Unit Townhome Project at Melrose
and Southport, 1994
Two drawings: 24 1/4 x 36 inches each

Paul Froncek
Howe Street Residence, 1993
Model: 38 1/2 x 18 1/4 inch base
Plan and elevation: 30 x 40 inches

Lakewood Avenue Residence, 1994
Model: 38 1/2 x 18 1/4 inch base
Plan and elevation: 30 x 40 inches

Doug Garofalo
Camoflage House, 1992
Derman House, 1992-93
Chen House, 1993-94
Dub House, 1993-94
Four models: 24 x 60 inch base
Four plans: 20 1/2 x 24 1/2 inches each
(framed)

Philip Hamp and Laura Hochuli
1960 North Howe Residence, 1987-91
Plans and elevation: 30 x 30 inches

David Hovey
Prefabricated Modular
Single-Family Housing, 1991
Five plans and four elevations:
15 x 22 3/8 inches each

Prefabricated Modular
Single-Family Housing, 1993
Drawings: Three plans and three
elevations: 15 x 32 7/8 inches each

Karen Johnson
Johnson and Wilson Architects
Schwab Residence, 1990
Karen Johnson, Fred Wilson, Thomas Jacobs
Rendering: 35 x 19 inches (framed)

Kaplan Residence, 1991
Karen Johnson, Fred Wilson, Thomas Jacobs,
Anne Cunningham, Fred Harboe
Rendering: 50 x 33 inches (framed)

**Phillip Craig Johnson and
F. Christopher Lee**
Moorehead Residence, 1989-91
Model: 11 x 5 inch base
Plan and elevation: 24 x 12 inches

North Kenwood Parade of Homes, 1994
Plans and elevation: 24 x 28 inches each

Ronald Krueck
Krueck & Olsen, Architects
The Miles Kerrigan House, 1981
Presentation drawing: ink on polyester film,
48 5/8 x 30 3/4 inches (framed),
lent by The Art Institute of Chicago,
Gift of A. James Speyer

Private Residence, 1985-86
Model: 28 x 31 1/2 inch base
Drawing: 42 x 54 inches (framed)

Roy Kruse
Roy H. Kruse & Associates Ltd. Architects
The Pointe at Lincoln Park, 1994-95
Timothy A. Deutsch, John Keating III,
Christopher V. Munro, Craig Neumann
Plan and elevation: 24 x 36 inches

Peter Landon
New Homes for West Humbolt Park, 1992-94
Plan, elevation and section: 12 x 18 inches

Howell Residence, 1993-94
Model: 13 1/4 x 29 1/4 inches
Plan and elevation: 16 1/4 x 21 1/4 inches each

Tannys Langdon
Deorge Residence, 1991
Model: 8 x 38 inch base
Three plans and one elevation:
10 3/4 x 13 1/4 inches each

Private Residence, Winnetka, Illinois, 1991
Model: 18 1/2 x 32 inch base
Three plans and two elevations:
22 x 22 inches each

Dirk Lohan
Devon House, 1992
Model: 16 x 16 inch base
Nine drawings: 35 x 31 inches (framed)

Lincoln Park Residence, 1992-1993
Model: 16 x 20 1/2 inch base
Two plans: 35 x 31 inches each

Michael Lustig
Nie Residence, 1994
Model: 38 x 38 inch base
Drawings: 24 x 24 inches (framed)

Exhibition List

James Mastro and Claudia Skylar
Glenn Residence, 1993
Model: 25 x 25 inch base
Three plans and one elevation:
18 x 18 inches each

Margaret McCurry
Tigerman McCurry
Tibberon Poster, 1988-89
38 x 12 3/4 inches

House for Burr Ridge, 1991
Model: irregular shape, approx.
66 x 42 inch base
Plan and elevation: 36 3/16 x 36 3/16 inches
(framed)

Private Residence, Michigan, 1993-94
Model: 12 1/2 x 12 1/2 inch base
Two plans and four elevations:
11 x 17 inches each

James L. Nagle
Nagle, Hartray & Assoc., Ltd.
Dunes House, Michigan, 1990
Model: 15 1/2 x 15 1/2 inch base
Two plans and one elevation:
22 x 17 inches each

Homan Square, Chicago, 1992
Plan and rendering: 18 1/2 x 23 1/2 inches each

Michael Pado
Cottam Farm, 1993
Model: 34 1/2 x 49 1/2 inch base
Plan and elevation: 28 x 24 inches

Private Residence, Michigan, 1993
Model: 25 1/2 x 43 1/2 inch base
Plans: 18 x 22

George Pappageorge
Pappageorge/Haymes Ltd.
Anderson Residence, 1993
Drawing: 30 x 40 inches (framed)

Nemickas Residence, 1992
Model: 25 x 25 inch base
Plans and elevations: 18 1/4 x 18 1/4 inches
(framed)

City Commons, 1986
Rendering: 30 x 40 inches (framed)

Frederick Phillips
Frederick Phillips & Associates, Inc.
Urban House, 1990
Model: 16 x 18 inch base
Four drawings: 21 x 21 inches each

Washington Island House, 1990
Model: 21 x 31 inch base
Twelve drawings: 8 1/2 x 11 inches each

Minakwa House, 1991
Model: 27 x 34 inch base
Four drawings 25 x 25 inches each

Kathryn Quinn
Michigan Vacation House, 1993
Model: 11 1/8 x 33 1/16 inch base
Two drawings: 24 x 30 inches each

Christopher Rudolph
Rudolph & Associates
Villa Bauten und Garten, 1992
Model: 24 x 48 inch base (irregular shape)
Plan: 13 x 13 inches
Four renderings: 42 x 42 inches each (framed)

Ken Schroeder
Schroeder Murchie Laya Associates, Ltd.
Urban Courthouse 1993
Model: 12 1/2 x 20 3/16 inch base
Two renderings: 8 x 10 inches (framed)

Telescope House, 1993
Model: 12 1/2 x 20 3/16 inch base
Rendering: 8 x 10 inches (framed)

Linda Searl
Searl & Associates
Lakewood Residence, 1993
Chicago, Illinois
Model: 12 x 11 inch base
Plans, elevations and renderings:
24 x 36 inches (framed)

Barker Residence, 1993
Hanover, Illinois
Model: 24 x 24 inch base
Plans, elevations and renderings:
24 x 36 inches (framed)

David Swan
Kennicott Place, 1988-91
Two plans: 20 x 16 inches (framed)
Elevation: 18 x 46 inches (framed)
Two renderings: 22 x 27 and
25 x 30 inches (framed)

Kenwood Gateway, 1986-94
Model: 22 x 28 inch base
Two plans and one elevation:
20 x 16 inches each
Two renderings: 18 x 30 and
30 x 20 inches (framed)

Stanley Tigerman
Tigerman McCurry
The Towers: A Tree Farm, 1988-89
Model: 37 5/8 x 8 5/8 inch base
Two composite drawings:
20 x 42 inches each

Roger Brown Residence, California, 1988-92
Model: 8 1/2 x 11 7/8 inch base
Two plans and three axiometric drawings:
30 x 21 inches each

Harlib Funerary Monument, 1991
Model: 9 15/16 x 15 1/16
Composite plan and elevation:
14 1/4 x 22 1/2 inches

Joseph Valerio and Linda Searl
2301 West Ohio Street, 1991
Joseph Valerio
Model: 34 x 20 inch base
Axiometric drawing: 18 x 12 inches (framed)

The Enigma of the Rooms, 1993
Joseph Valerio, Randall Matheis and
David Jennerjahn
Model: 36 x 36 inches
Plans: 50 x 38 inches

Wilmont Vickrey
VOA Associates Incorporated
Vickrey Residence, Michigan, 1993
Plans and elevations: 30 x 40 inches (framed)

John Vinci
Office of John Vinci, Inc.
Manilow Residence, 1991
Max Gordon and John Vinci
Model: 52 x 64 inch base
Plan, elevation, section and detail:
30 x 44 inches each

Wetsman Residence, 1994
Model: 44 x 48 inch base
Plan, elevation and section:
30 x 44 inches each

Cynthia Weese
Weese Langley WeeseArchitects Ltd.
House in the Woods, 1983-84
Assemblaged model and drawings:
36 x 32 inches

Catherine Wetzel and Nabil Zahrah
House at 2444 North Talman, 1991
Model: 5 x 7 1/2 inch base
Plan, elevation, axiometric and rendering:
20 x 28 inches each

Daniel Wheeler
Wheeler Kearns Architects
Indiana Dune House
for Extended Family, 1991-92
Model: 40 x 7 inch base
Plan, elevation, section, rendering:
21 x 21 inches (framed)

Winnetka Residence, 1992-93
Models: 15 x 21 and 7 1/4 x 17 3/8 inch bases
Plans and section: 52 3/4 x 15 inches (framed)

Live/Work Structure, Chicago, 1993-94
Model: full-size mock-up section of cast
concrete wall with insulated core
Plan, elevation and axiometric drawings:
8 1/2 x 11 inches each

My husband and I have a deal. He used to be a contractor. That means he's built a lot of houses for other people. It also means that one thing he wants very much to do now is to build a house for us, for his own family. This is not something I want to do.

The idea makes my blood run cold. But it's marriage; you listen to your partner. So what we have is a deal. He wants to build us a house. Fine. We get the divorce first. Then, once the house is built, the windows are in, and the floors are down, if we're talking to each other, great. If we're having dinner once a week, better yet. Maybe, eventually, we'll move in together and live in this beautiful house that he's built us.

I don't think this scenario is farfetched. I think building houses is right up there with money, sex, and kids –all better– catalogued reasons that partnerships dissolve. And I believe it's because people disagree so profoundly about what gives them comfort.

For me, the comforts of home are inextricably linked with history. Seven years ago we moved into a house in upstate New York. The house was built in 1792, and I can't imagine ever living in a house that wasn't two hundred years old. I would find it odd to live in a house where no one has ever lived before. My husband's way of finding home is more assertive, less preoccupied with a sense of continuum. In our family, the dialogue about comfort has to do with whether it's about inventing a sense of fit or distilling it from tradition.

While it may be the latter for me, I am perfectly well aware that my beautiful 200-year-old house makes no sense for the way we live today. When you talk about the comforts of home, you inevitably start talking about houses and history. Because what we mean by comfort has evolved just as surely as our houses have. My house is a small center-hall, colonial farmhouse. This floor plan, with its formal front door and dining room and no closets to speak of, rarely conforms to our contemporary needs.

The center-hall colonial was not just a building type; it was a pattern for living. You walk in the front door. There's a living room on your right, a parlor on your left. The kitchen is somewhere in the back, along with the utility room and other service spaces. The private domestic space, the bedrooms, are upstairs. There is a clear and logical progression, passing from public to private realms, to the way space has been arranged.

Trying to live reasonably in such a house in 1994 poses its own challenges. And it's made me question what our contemporary ideas of comfort are exactly. What I realize, of course, is that today there is a different logic. It's more idiosyncratic and more difficult to map. The phrase "comforts of home" is nonspecific. There is no single pattern or single cultural definition for comfort. Like so many other things today, it's a question of personal choice. Some friends of mine recently built a house, and midway through construction they realized that they each had entirely different notions of comfort. To the woman, it had to do with light and space; if she had an idea home it would be built of glass on a mountain top. Her husband wanted a cave, a warm, secluded space. His idea of comfort was about a sense of physical containment and security. So they found a way to compromise, with an airy, light-filled open kitchen that flowed into the living area and a more secluded loft space contained within the peak of the roof where he could find a little privacy.

But in the geography of home, mountains and caves may be the least of it. The landscape of home has shifted in recent years, its contours reshaped in more subtle and significant ways, reflecting the changing structure of the family; the growing numbers of people working at home; new attitudes towards privacy, security, and home safety; and a nascent respect for the natural environment.

At the same time, nostalgia remains a powerful force in the way we think about home. With some 300,000 readers, *The Old House Journal* sells historic house plans from all periods of American architectural history. None of these plans includes exercise rooms, home spas, or atriums, some of the spaces people seem to want today. The magazine's advertisers sell everything from reproduction Victorian hardware to Amish cookstoves. Never mind that these archaic furnishings and floor plans don't acknowledge any of the economic and social issues that are reshaping our ways of living and working; people still want them. So any definition of home today must consider how new attitudes and values come up against the familiar; how our needs are served by what we know as well as what we are nostalgic for.

Begin with the front door. The formal entry to my 200-year-old house has an airy transom and a glass surround. This is not safety glass, but sheets of handblown glass supported by ornamental iron scrollwork. The inevitable comparison here is with the glass lenses of the tiny peepholes used to check out visitors in most modern urban apartments, and it suggests that the comforts of home today are to some degree defined by a sense of security. The front door was traditionally designed to present the house to the world at large; to be welcoming. Once it was the generous, hospitable part of the house. Today, as we retreat from a world that is increasingly disturbing and chaotic, we tend to view our homes more as shelter and retreat.

For the same reason, the glass boxes of some modernist residences may be as much of an anachronism as my colonial farmhouse. If the sense of being protected is part of our modern notion of comfort, the modernist vernacular of exposed structure and glazed partitions, for all their natural light and sense of openness, in the end may leave us feeling exposed and vulnerable.

Similarly, the congeniality of the front porch has been replaced by the privacy of the deck behind the house. The front porch and stoop were both once ambiguous territories, private and social at once. It was an ambiguity we could afford then. Today, as we increasingly perceive our homes as fortifications, this congenial interface has been replaced by home-security systems, the electronic version of the medieval moat. The sense of graciousness and congeniality with the neighborhood has become less important. Rather, feeling physically safe and protected figures into our ideas of comfort.

Too, like the beautiful, ceremonial front hallway it leads to, the front door is rarely used. What we do is drive our cars around to the side of the house and come in through the back kitchen door. The automobile has reoriented the house. So from the start the sense of logical progression these old houses embody is disrupted.

The strange part about it, though, is that we keep on designing and building front doors. There's a middle-income development up the road from where I live. Each of the fourteen houses occupies a half-acre plot on either side of the access road. Eclectic American is the term that best describes the developer's wide, if imprecise, range of architectural references. Each house has a two-car garage, and the door that leads from it to the interior is the major entryway. But each of these houses still has a front door. Some are sheltered by gables, others have little steps and porches; one has a metal entry porch roof that evokes the regency style. But no one ever uses them. All the same, we keep on building front doors; it seems we want to keep the ceremony of arrival in our lives, even if it's just a memory.

Once you get into the kitchen, you find that it's a place of paradox in most contemporary homes. The modern kitchen is at once a high-tech lab and a hearth. You might think that with all the labor-saving equipment we have today, the kitchen would be relatively small. But to the contrary, the kitchen has a newly regained central position in our homes. One reason it's become so large again may be that we need space—for all the equipment.

Like plastic and polyester, processed foods represent a kind of poverty of spirit; so at a time when every kind of food and drink is available prepackaged, we buy juicers, pasta makers, coffee grinders, compact bread ovens. When processed foods were first introduced, they were a luxury intended to liberate housewives from unwanted domestic labor. Today's luxury, it seems, is to do it yourself again—when you can choose the chore, the time and place it's done, and when you have the right appliance to help you do it. Today, these labors also cross gender lines. A surgeon I know often begins his day by baking fresh English muffins. A screenwriter I know finds peace preparing dinner for his family. In many newly designed kitchens a desk, home computer, and bookshelves appear as well; a homey sort of work station. What this suggests to me is that we find a solace in the rituals of the kitchen; domestic chores may give us a sense of continuity. And if we don't find this comfort in baking a loaf of bread, we'll bring some other kind of work into the kitchen.

That the kitchen may serve as an office is in keeping with the changing floor plan of the American home. Modernism taught us to be more flexible with space. Boxlike interiors like those in my 1790 house gave way to more fluid spaces less rigid in their function. But there is more to it than that. In 1960 the nuclear family accounted for some fifty percent of the active housing market; today it hovers somewhere around fifteen percent. The other eighty-five percent is made up of single people, working couples, unrelated adults living together, retired people, and single-parent households. One obvious change in the floor plan of home that reflects these new households is that people don't have the time or interest in keeping up a large house—so the kitchen becomes a sitting room and you have a single space that combines living, dining, and family rooms.

A recent survey done by *Metropolis* magazine asked some 350 people to talk about how they live. More than half of the respondents were urban dwellers, so their cramped apartments naturally colored their ideas of home. But the respondents described how they use the bedroom as an office, the kitchen as a living room, the hallway as a sitting room, the living room to eat in, the dining-room table a place to put the computer. We put a high value on rooms and furniture being multifunctional and flexible. To some degree, that defines our idea of comfort.

In the bedroom, however, this multifunctionality can sometimes get out of hand. The bedroom may express a sense of confusion about what gives us comfort. The survey suggested that people spend much of their time in the bedroom. When asked, "When you think back to your childhood, what room do you remember most fondly?" most people recalled that it was the bedroom. "It was mine," one said, or "It was where I could be alone" or "where I could go to be me." It was, in other words, a refuge and a retreat. Today's bedroom serves a myriad of purposes, but rarely is it a refuge. Rather, the bedroom looks like the place where we want it all—books, telephone, television, VCR, exercycle. Often it is a home office as well. The room where we found sanctuary has today become a gym, a theater, an office.

Designers and architects are asked to consider the fact that people use their bedrooms for so many other functions. But a different group of professionals is asked to consider this as well. These are doctors who treat sleep disorders. Because, not surprisingly, as people do more in the bedroom they rest there less. As a result, doctors advise insomniacs to take irrelevant activities out of the bedroom. "The bedroom is just for sleeping and making love," one doctor told a friend of mine. "Don't read there. Don't watch TV there. Don't ride your bicycle there. Don't do anything else there." In essence, what the doctor was telling my friend was that as the landscape of the home shifts, we can't afford to forget the natural function of the bedroom as sanctuary.

The same survey asked people what room they most wanted to add to their homes. Most of us, it seems, need a little history in our lives; traditional domestic spaces like solariums and music rooms were mentioned as often as spas, lap pools, and home offices. But the room people seemed to long for most was the traditional library, a private place to linger over the pages of a book. Call the library an anachronism; the place we store knowledge today is not a room, but a computer disc. The change from physical to electronic space signals one of the ironies of postmodern life—the more information we have, the less space we need to put it. The personal computer is in more homes than the personal library ever was. Wealth and class no longer determine to the same degree who has knowledge.

The ultimate home library is probably the Internet, the largest collective computer network in the world that some thirty million users can plug into with the PCs to access information on everything from up-to-the-minute political analysis and scientific research to information on childrearing and recovery programs. Yet with all this available, people still seem to long for a traditional library. And I wonder if it is because this was a more solitary place. The acquisition of knowledge for our forebears was not interactive, and I suspect the privacy of reading is something people miss. But that's only one difference. In the descriptions of old English libraries, you read about polished mahogany cabinets and shelves, soft leather sofas, overstuffed armchairs. To me, this describes an atmosphere of security and comfort.

That sense of comfort is absent at our computer terminals.

Educational software, whether it's about human anatomy or music or geography, is often packaged as an adventure in learning. Learning is exciting, exhilarating, challenging. But it is not necessarily comforting. We describe our computer terminals as user-friendly; this is not the same as being comfortable. And that we neither look for nor find this same comfort in knowledge may be the most fundamental difference between the traditional library and cyberspace. It may also be why so many of us seem to long for a traditional library.

The amount of space given to storage is another change in the floor plan of the contemporary home. In my old house there are no original closets. The three closets that do exist were all jerry-rigged into the house over the years as additions and renovations were made, and there is still not enough storage space. The people who built this house were not in a society of consumers and savers as we have become. Walk into a historic house from the seventeenth or eighteenth century and you sense that the spareness and lack of clutter is what makes them beautiful. There is a row of pegs on the wall for coats, open shelving in the kitchen, a wardrobe or trunk for clothes. What people needed they kept within sight and within reach. The inclination to hoard had not yet set in.

Oddly enough, the modern movement reflected a similar austerity when it came to storage space. Frank Lloyd Wright found closets subversive and called them "unsanitary boxes wasteful of room." In his 1894 speech to the University Guild in Evanston, he observed that "housewives erroneously gauge convenience by the number and size of dark places in which to pack things out of sight and ventilation. The more closets you have, the more you will have to have and, as ordinarily used, they are breeders of disease and poor housekeeping."

While most architects of the modern movement didn't accept the notion that closets breed disease, they were disinclined to make room for storage space. In part they were encouraged by the socialist tenets which held that sharing the world's wealth meant fewer possessions for everyone. Too, their multifamily housing made with reinforced concrete and steel framing eliminated the need for interior load-bearing walls and allowed for open interiors shaped only by the well-placed column or movable partition. There was an integrity to the way exposed frames revealed the methods of construction. Closets, meant to conceal things, were accommodated by neither the building techniques nor the ideals of modernism.

All that has change today. It has become a cliché to point out that we are a society that defines itself as much by what we have as by what we do. Aside from the library exercise room, the people we questioned for our survey begged for more storage space. Move into an old house and one of the first renovations you make is to add storage space. That's the least of it. In the rural area I live in, there has been a proliferation in recent years of storage-unit rentals, compartments leased by the square foot to store all the things you don't have room for at home. This is a brand-new industry, and the people in it, like casting directors and food stylists, are in a profession that would have been inconceivable fifty years ago. With their charming gambrel roofs and window boxes, these storage barns take their stylistic cues from the farm. Yet the livestock has been replaced by stuff—lawnmowers, cars, furniture, household appliances, pianos, paintings, whatever.

Mass production makes it easier and cheaper to own more things. Too, as we become a more transient society, we tend to define home by our things rather than by place. But I suspect the increasing need for storage space also reflects an altered relationship with our possessions. My own suspicion is that Freud got us started on all this. The father of psychoanalysis was the first to put a high value on the personal past, that realm in which the secrets and mystery of our identity reside. And so we have grown to appreciate what we can remember, and the more of it, the better. "This is the place to put the things you don't need but that you can't throw away," says the promotional copy for one company selling aluminum storage barns, and I think these words may apply to psychotherapy as well.

In learning to live with our emotional past we value its physical artifacts as well. The more we personalize our possessions, the more we are able to see ourselves in them. And once we have invested ourselves in the things we own, it's difficult to be rid of them. And so we've developed this compulsion to have things and to hang onto them. The storage space that allows us to be surrounded by our possessions is another factor in our modern notion of comfort.

The home office is another recent addition to the domestic landscape. A recent study tells us that one in three Americans now works at home at least part time—whether it's on account of flextime, corporate downsizing, child-care demands, or the ease with which modems and faxes have enabled many people to work independently. Yet home work is not just a question of how many phone and fax lines you need but one of how this work space can be really integrated into the patterns of home life.

Possibly, this may involve sensory experience. In her book *A Natural History of the Senses*, author Diane Ackerman observes the habits of various writers and how they courted the muse. Katherine Mansfield gardened and Edith Sitwell would lie in an open coffin before she sat down to write. The poet Frederick Schiller kept rotten apples in a bureau drawer; when searching for a word, he found that opening the drawer and releasing their pungent bouquet released a new reserve of creative energy. George Sand went directly to her desk from making love, while Colette found picking the fleas off her cat was the appropriate prelude to work.

Ackerman argues that even the briefest sensory experience can nurture the imagination. And I think this will become more important in the electronic home office as direct experience and face-to-face contact become a less important part of getting the job done. Even something so convenient as a fax machine has us giving up the spontaneous exchange that can occur during a telephone conversation. The beauty of the home office may be that it's a place that can accommodate personal, sensory experience in a way that the corporate office obviously cannot. As we continue to bring our work home, the greatest challenge may be to put aside questions of where to put the printer or how many electronic cables are needed, and ask instead how home and work can be integrated in a more sustaining way.

Maybe home work will eventually be a balance of gardening, smelling a drawerful of rotting apples, and plugging into the Internet. Maybe the ultimately peaceful bedroom will be a refuge where there is simply a bed and a CD player to play soothing music. Maybe the beautiful sidelights and transom of my entryway can be reconstructed with safety glass, giving me both what I want and what I need.

The closest I can come to knowing what comfort means today has to do with recognizing and resolving these incongruities. Comfort today may be the graceful coexistence of nostalgia and technology. And we may need to recognize that there is no necessary dissonance here. There is bound to be some confusion. My children watch Terminator movies on a TV set that is housed in a Shaker-style cabinet. There is a certain postmodern charm to that. But such confusions can be more jarring; we tend to reject the formal ceremony of the dining room and put the computer on the dining-room table or sort laundry there. But then we miss the sense of ritual in our lives and find ourselves delving into the rituals of Native Americans or Tibetan monks.

Such incongruities can confuse our lives. But I would argue that they are also the very basis for finding comfort at home. If anything, I think that home can be a place that celebrates and thrives on incongruities that have, in one way or another, been gracefully resolved. This is what I would think of as fit. I've always thought design was, essentially, about finding ways for things to fit—how a fork fits the hand, how furniture fits the body, how buildings fit people. Design, most of all, may be about finding this sense of fit between people, places, and things. If you think of design as being about fit, you consider not only the physical dimensions but the moral and social ones as well.

Here is an episode of unexpected fit. It is about my neighbor and a tape she listens to. She is not a techie. She is a widow in her seventies who lives alone. And like many people who live alone, she's free to explore her own idiosyncracies about what makes her happy, or comfortable. I went to visit her recently. It was a stormy November day and I was expecting her to be enjoying a cup of tea by the fireplace. But instead, she was sitting in her living room, listening to a tape of the ocean. You could hear the surf and the gulls. "I find it so peaceful," she told me.

There is something incredibly modern about this vignette, the way someone who is not of the technological age can use technology to find a little comfort. Talk about space being multifunctional! She had found a way to bring the shore to her little inland bungalow. This is the image of contemporary home I find most compelling; it's a landscape where, though you may be hundreds of miles from the ocean, you can find the peace that comes from listening to the waves. That's what I would call comfort.

This essay has been adapted from the series "Geography of Home," published serially by *Metropolis* magazine from March 1993 through May 1994.

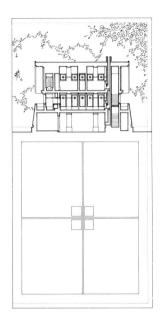

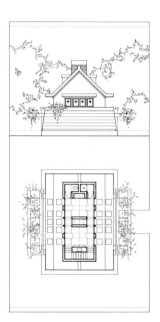

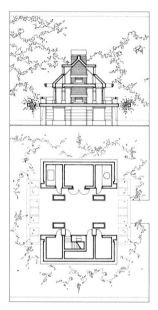

Located on the northern shore of Lake Michigan, the Shields Vacation House is built to serve as a year-round retreat for the enjoyment of summer and winter recreational activities.

The house is situated at the edge of an uncleared forest of aspens and conifers. It is built on a relatively level rock shelf slightly below the crest of a hill and at the top of a rocky ravine which slopes down to the lake less than one mile away. Invisible from the road, the access drive curves around the property and approaches the home from behind so as not to intrude upon its splendid sense of isolation.

Intended as a temporary residence to be used for several years as such, the house represents the first phase of a planned estate in which it will later serve as the guest lodgings (with the main home positioned closer to the top of the hill).

The fundamental aspect of the design is found in the vertical organization of the house. Carport, storage and utility functions are grouped on the ground floor, thereby elevating the living areas. The house is entered from underneath and access is gained to the second story via a winding staircase. Here, the living room is surrounded by an outdoor deck which mediates between the interior and the landscape. In addition, the third-story sleeping areas are treated as a loft above so that the volume of the interior may be read as a single continuous space.

In this way the natural surroundings and a sense of openness are used to achieve the feeling that the house is much larger than the dimensions would indicate. A place to share in the beautiful setting is created despite the strict utilitarian program.

William Daniel Allen
Shields Vacation House, 1990-91
Brevort, Michigan

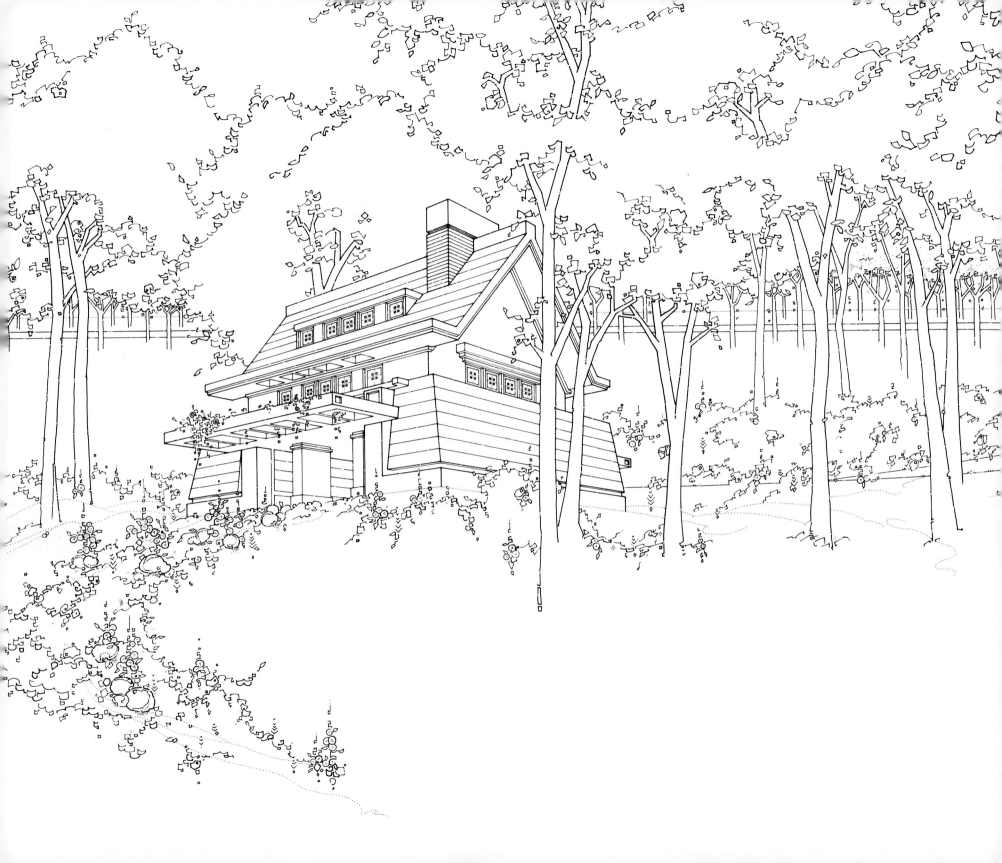

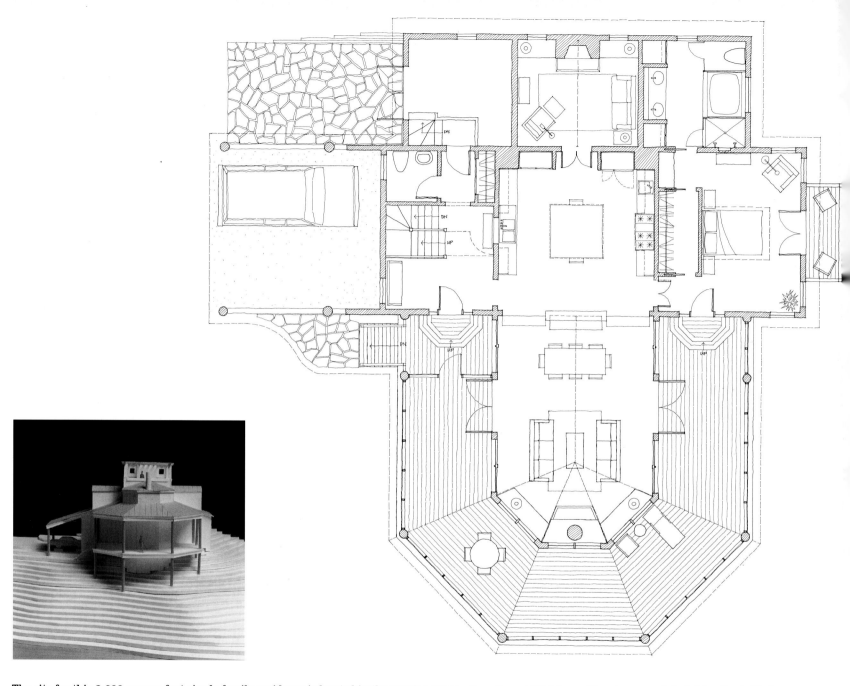

The site for this 3,600-square-foot single-family residence is located in the wooded dunes of southwest Michigan. The steep wooded plot is situated between two small lakes with the majority of its area deemed "unbuildable" by the state's stringent environmental laws. The top of the dune is small but buildable, with spectacular natural views to the east, south, and west.

The owners are a prominent couple who own a nearby restaurant. Their children are older and live away from home. Their program called for an eat-in kitchen, a master suite on the main floor, a great room expandable into a screened porch, an office and billiard room convertible into bedrooms, a cozy den, and a two-car carport.

The concept for the three-story structure was driven by the very limited building area and the beautiful 180-degree views. A compact footprint was devised for the ground floor containing the billiard room and bath, doubled in size by cantilevering the master suite and adding the porch with columns and beams. The heart of the home is centered, containing a professional kitchen surrounding a custom dining table. The intimate kitchen overlooks the great room with its wraparound screened porch, clerestory windows, fireplace, great room, and porch. Adjacent to the kitchen is the master suite and den. The second floor is essentially a loft bedroom/office and bath. Ascending to the roof there is a trellised room for star gazing and bird watching.

John Banks and Garret Eakin
Racine Residence, 1993
Grand Mere, Stevensville, Michigan

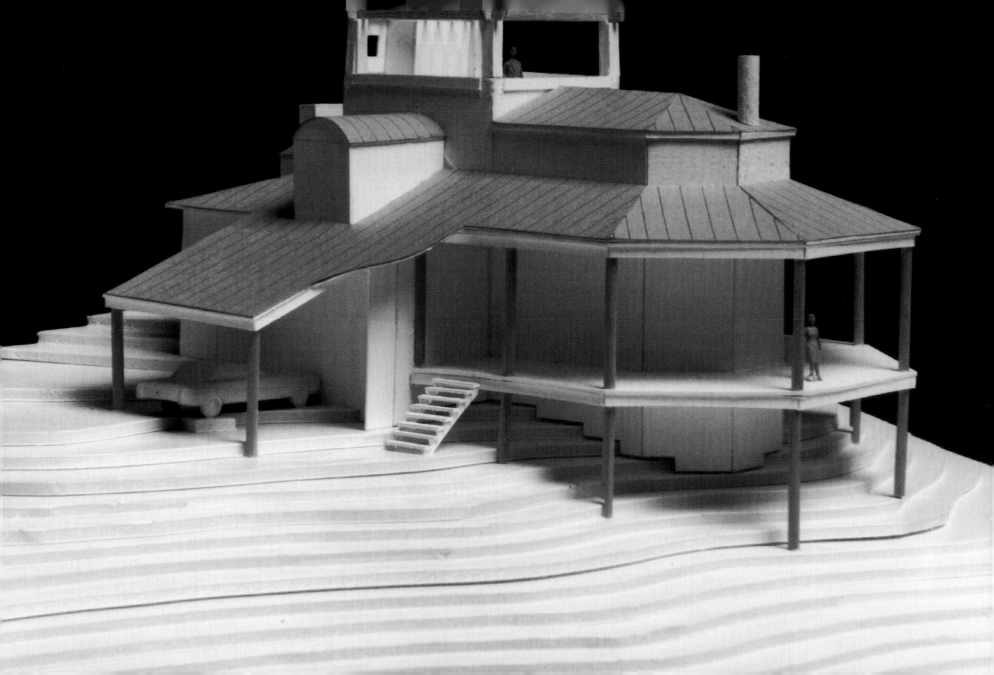

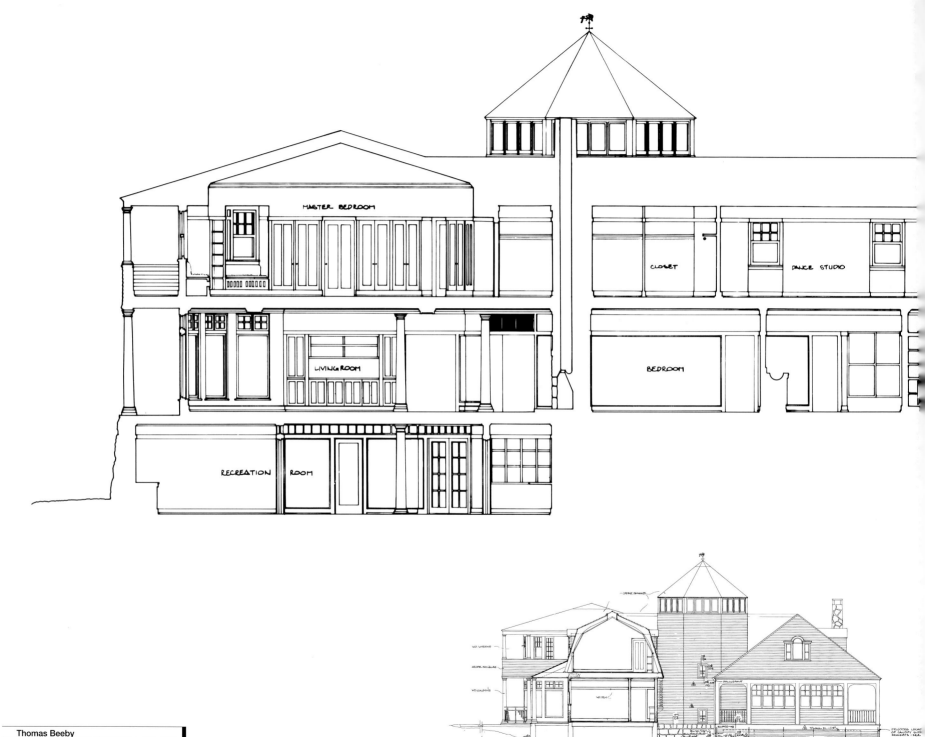

MASTER BEDROOM

CLOSET

DANCE STUDIO

LIVING ROOM

BEDROOM

RECREATION ROOM

Thomas Beeby
Old Quarry Residence, 1993
Guilford, Connecticut

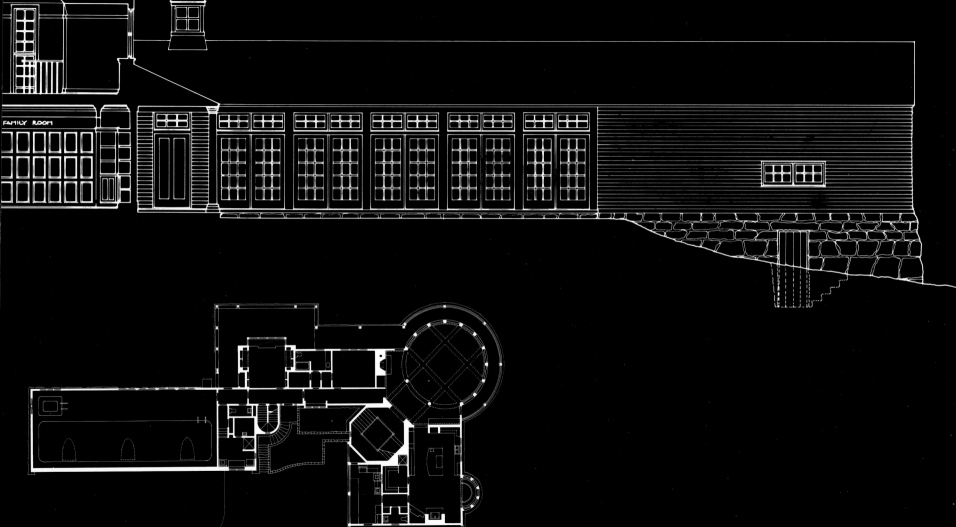

FAMILY ROOM

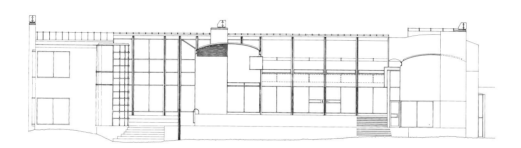

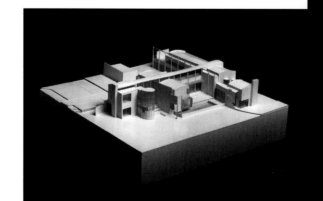

The design of this 7,000-square-foot residence was made to respond to a landlocked site, with neighboring lots on three sides and a creek on the fourth. The creek lies at the bed of a flood plain, which covers seventy percent of the site. Presenting no image to the street, the residence is approached by a narrow drive across the lot to the south. This opens up to the house, which is sited on the high point of the site. The focus turns inward away from the neighbors, while turning outward across the wooded lot to the creek.

The program required separate areas for the owners, their children, guests, and entertaining. Each use has become a distinct form in the design, grouping themselves along a two story central spine. This vaulted element contains an elevated exterior walk which continues inside as a glass bridge. This walk connects, through sequenced means, the master suite to the north, with the private librar to the south. Courtyards are created among the elements of the house, including an extensive auto court and garage for the owners' collection of fine cars. The many elements of the house are tied together through the consistent use of steel, glass, and stucco detailing

Darcy Bonner

Himmel/Bonner Architects

Eagle Residence, 1986-87

Dallas, Texas

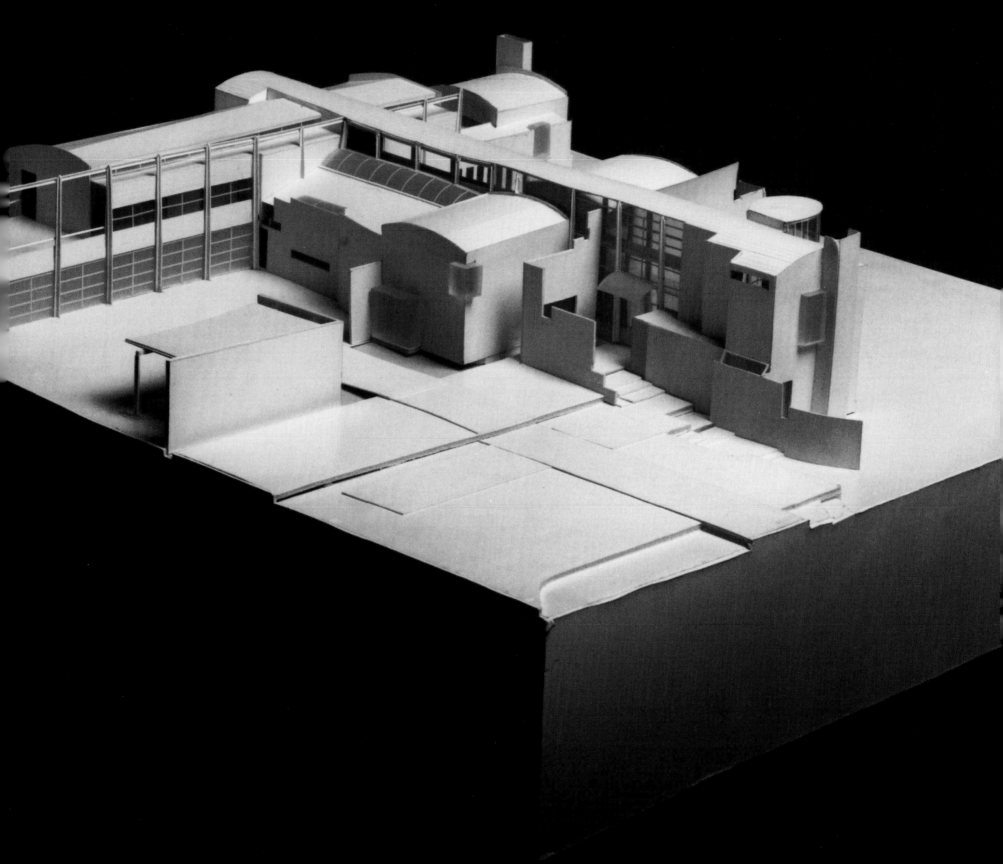

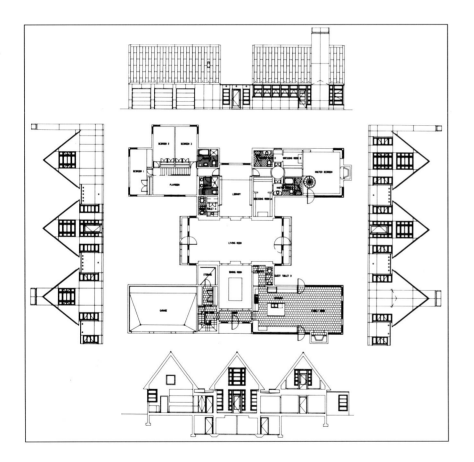

Fragmentation may be understood as a "freeing up" of the parts, allowing each component a wider range of possibilities.

While houses are not the largest buildings, they are close to the most complex. Houses combine a wide range of needs, a wide range of spaces, and a wide range of experiences.

Organizing a house into components that are discreet, simple to build, and flexible allows each part the most opportunities while providing durability and economy.

This house organizes into five pavilions—living, family kitchen, garage/service, master suite, and children's pavilion. Each piece is constructed as a simple "house form," hence the title "Five Easy Pieces."

Laurence Booth

Booth/Hansen & Associates, Ltd.

Five Easy Pieces, 1994

Highland Park, Illinois

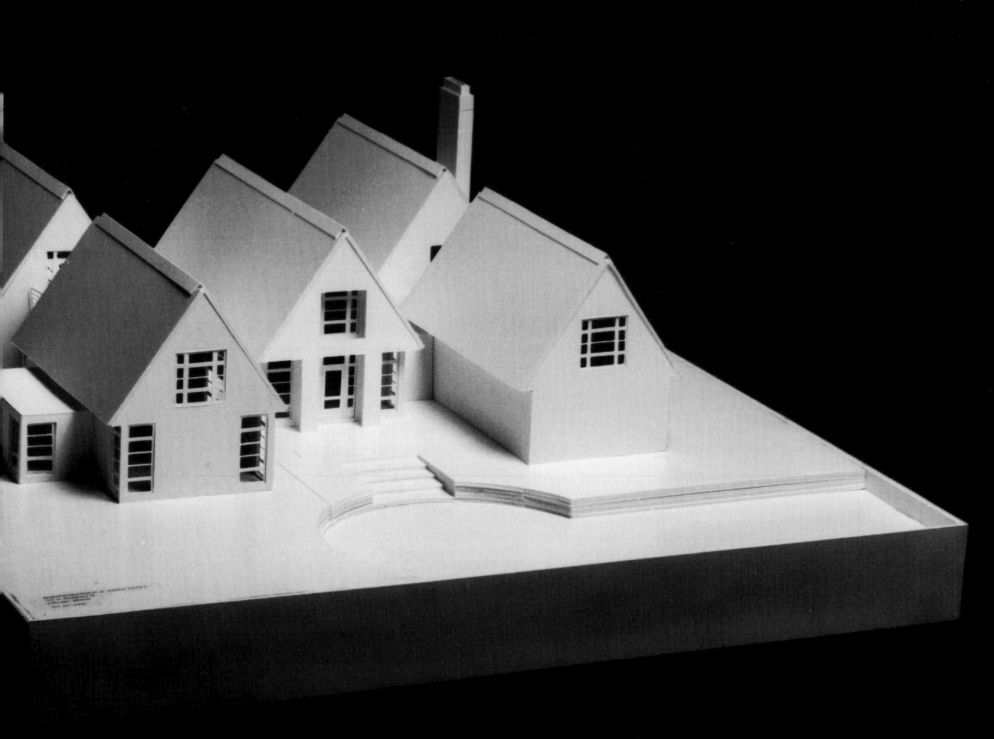

The vacation house we designed in Grand Beach, Michigan, sits on a bluff facing Lake Michigan and fronts a residential street of summer houses and year-round residences. It extends wall-like along the street, with small high windows on the first floor providing privacy. The house is designed to face the lake, and the rear facade at the first floor is a continuous row of transom-topped French doors and tall casement windows. Each room of the house faces the water and each room—bedrooms as well as living rooms—opens to an outside terrace or roof deck.

The living room is a beamed "great room" reminiscent of the interiors of English arts and crafts cottages. At one end of the room the wall is dominated by a fireplace flanked by cabinets and bookcases. At the opposite end is a built-in bar. The window-wall of the living room is designed to visually slide by the back wall of the space linking it to the dining room, which is a glass-enclosed octagonal space that bays out from under the volume of the house above. A breezeway connects the garage to the house and allows access directly to the back wall with a shower and changing room for guests returning from the beach. The breezeway also allows access directly from the street to the yard and beach without going through the house. The top of the garage forms a south-facing deck off the master bedroom partially sheltered by a roof extension.

The house is clad on the exterior with six-inch lapped horizontal siding with mitered corners, painted white, and has a cedar shingle roof.

Stuart Cohen and Julie Hacker
Private Residence, 1993-94
Grand Beach, Michigan

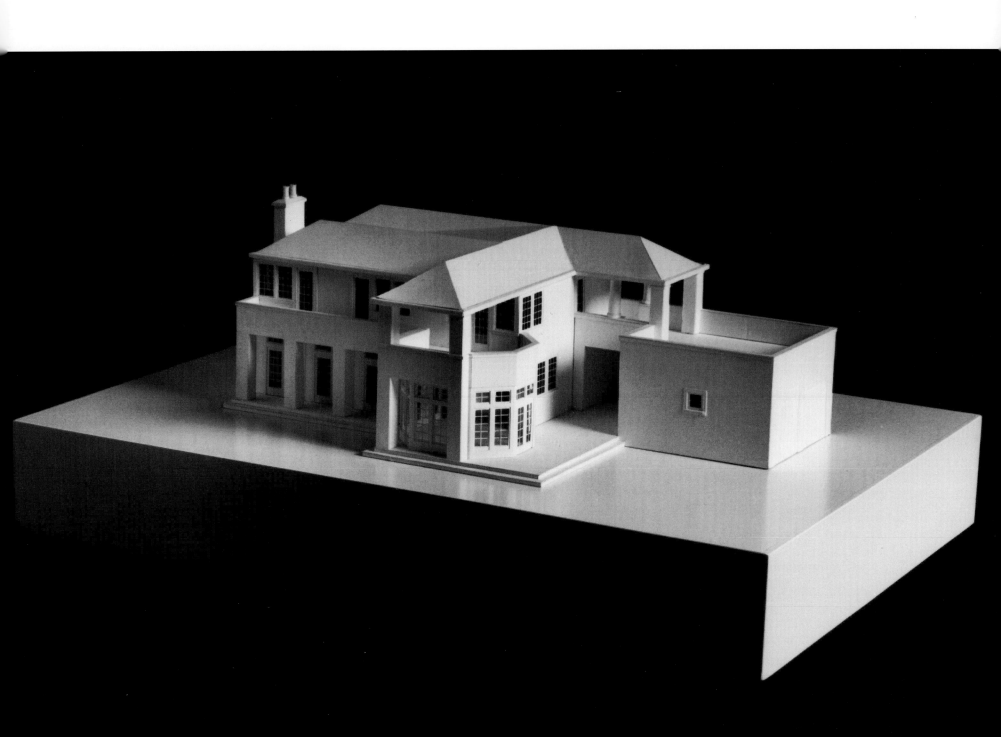

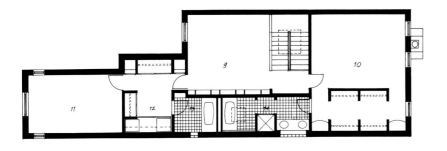

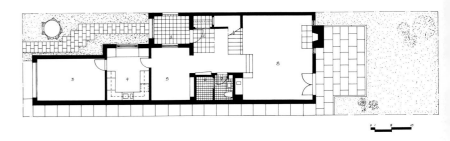

This project, built on a lot measuring 25 by 102, responded to five major requirements: 1] the neighborhood, while undergoing gentrification, was in a marginal area; 2] there was no rear alley for a garage, and street parking in the neighborhood was difficult at best; 3] a four-story American elm tree dominated the northwest (front) corner of the site; 4] concrete block in various finishes was to be used for its urban character and relatively low cost; 5] there was a limited budget. As a result the house was designed and built around the elm tree and the garage was placed at the west (front) of the site. This configuration initiated a sliver courtyard leading to a semi-enclosed front entrance. Moving through this small garden area not only provides a transition area from the city, but also allows natural light to permeate the kitchen and dining room.

Materials historically used only for warehouse and industrial structures were combined in various patterns to create a unique stonelike facade. The exterior was purposely designed to keep the city at bay. However, this restrained street facade is a mere mask for the interior light and warmth of the home.

| Susan Conger-Austin |
| Conger-Austin Residence, 1989 |
| Chicago, Illinois |

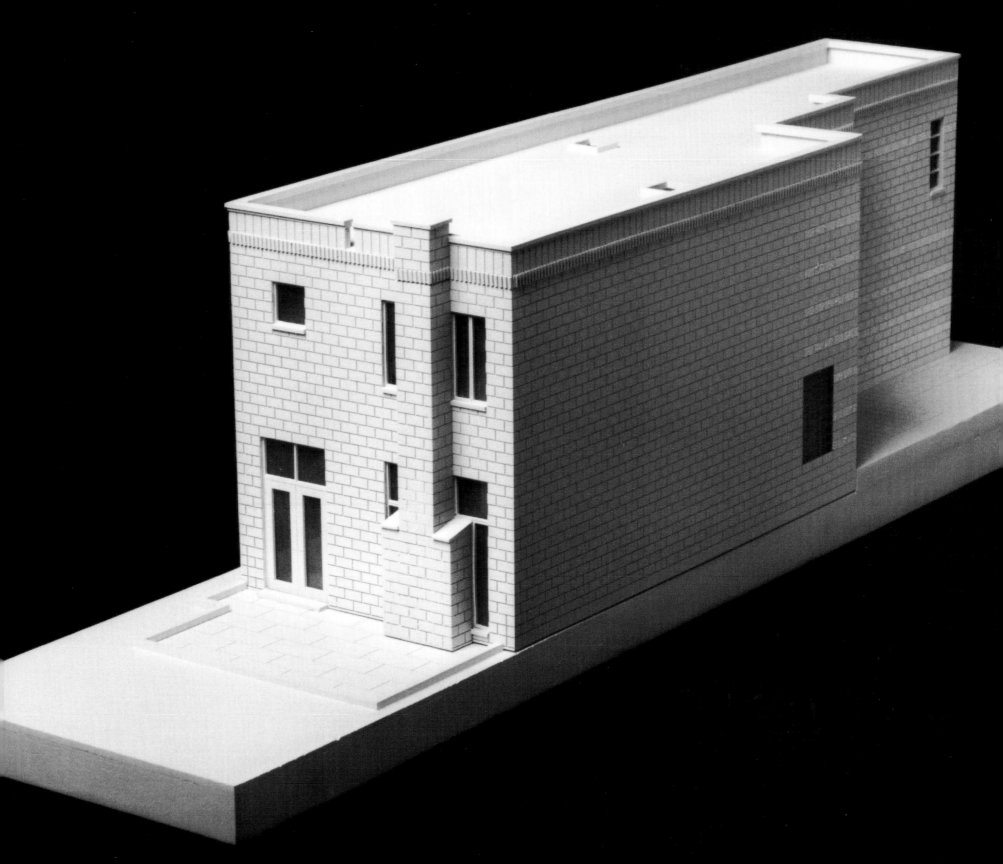

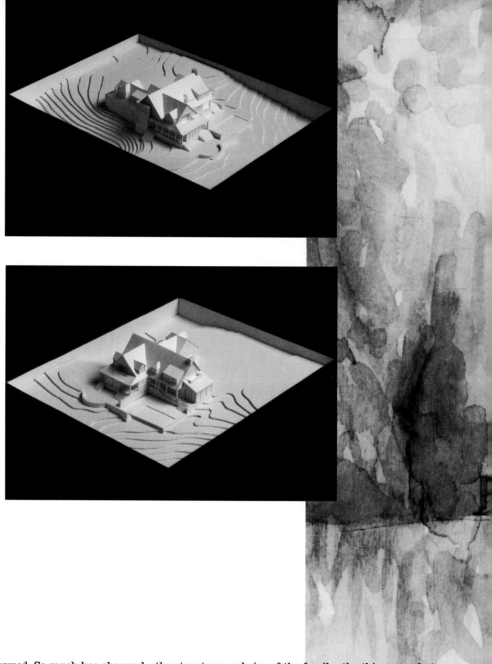

Since the last time a century turned, the home and hearth have been transformed. So much has changed—the structure and size of the family, the things we do to earn our sustenance, even the way we care for and keep the life of the house. Many machines have found their way into our lives, and thus into our households. We use these machines to do the work of cleaning and maintaining and transporting us, even to the heavens.

Accordingly, the order and arrangement of the rooms have been altered. Whether a house is big or small, often we no longer live in the living room or dine in the dining room. Now we live in the kitchen, the great room, and the family room. We work, sometimes every day for our livelihood, in the study, the library, the computer room above the garage. We entertain ourselves in the media room, with the walls alive with moving pictures.

But some things have not changed. We still seek warmth and shelter from the storm-tossed world outside the family and the fireside. When we can, we still seek to experience the natural world from our windows, capturing the change of hour, of season, of weather. And we seek more than ever to live in homes that look like they connect us to a meaningful, memorable past. Perhaps because of the pace with which our lives and families have been transformed, we seek in the extension of our houses some anchor against a sea of change.

Thus the house at the turn of the century is radically different on the inside, with new kinds of rooms in new kinds of relationships, new machines to create a perfect and stable interior environment and to help us with our work. And on the outside, with forms and materials that remind us that though we have changed, we are still a part of the life of families and homes that have come before us.

| Howard Decker |
| DLK |
| Architecture, Landscaping, Planning |
| Lot 12, 1994-95 |
| New Buffalo, Michigan |

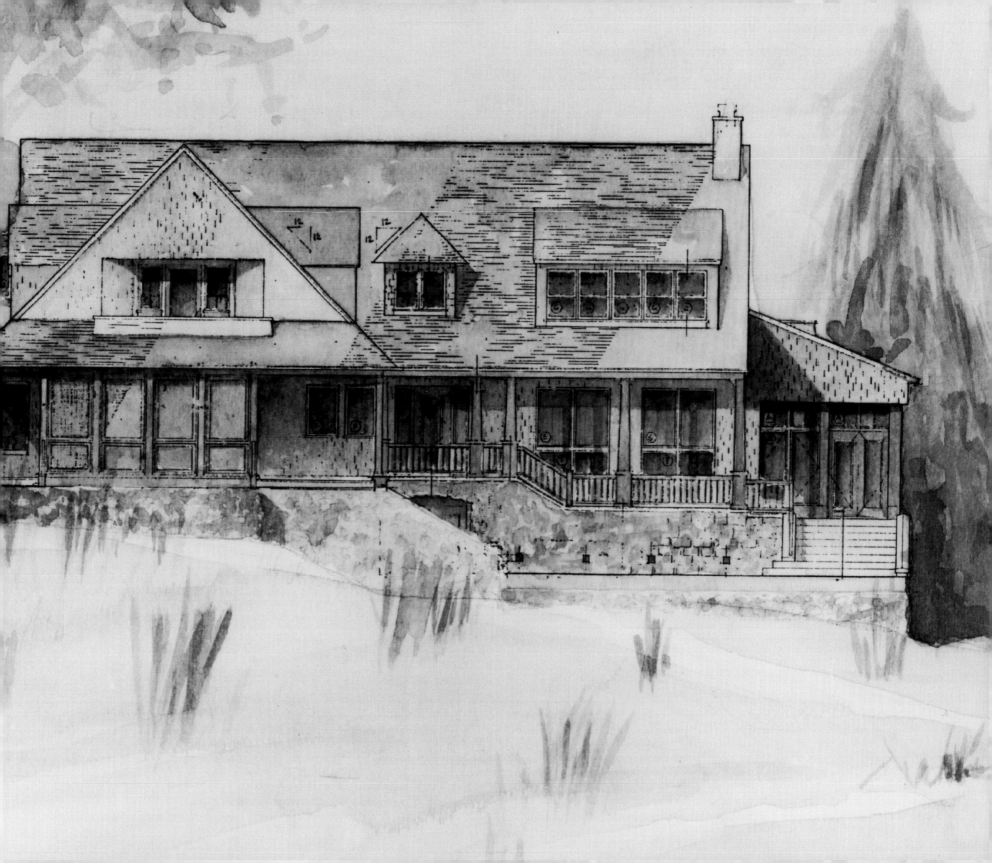

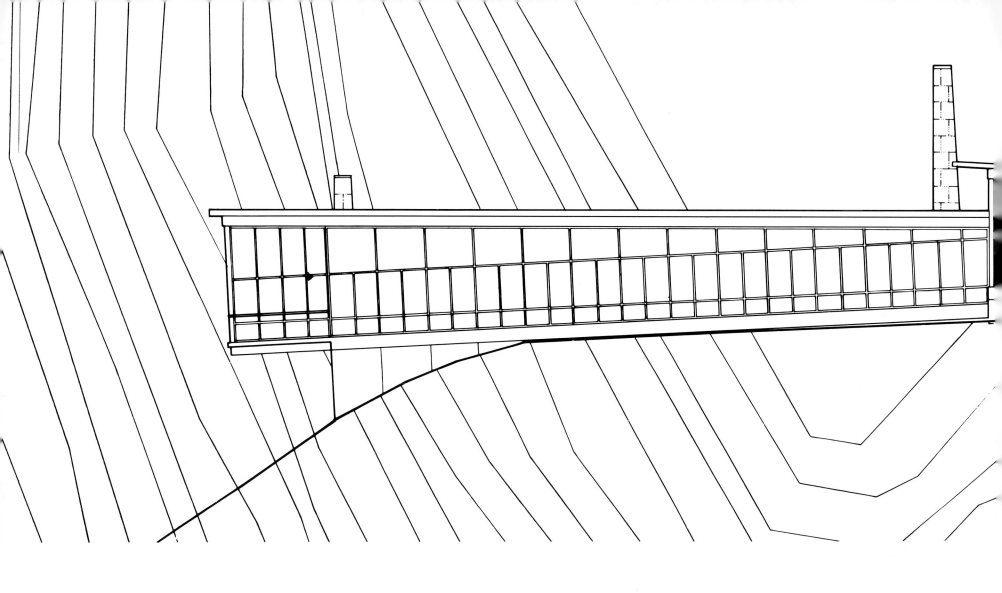

The primary desire was to establish in this design a consciousness that reverberates between the perception and experience of place, space, and object, creating a structure which continually speaks about its ability to foster opportunity. The dynamics of this consciousness were initiated by the features of the given site; the nature, needs, and desires of the owners; and an awareness of our current condition.

The exterior embodies the desire to impose modestly upon the land. The interior works to be straightforwardly functional, while dividing the occupied spaces between those of a public nature and those of a private one. The sequence of entry takes a route through an orchard grove, which, like a mask, all but eliminates the legibility of what is beyond. With determined approach, a reflective, inclined wall is discovered and has inscribed upon its stone surface the accomplishments of a lifetime. The entrance is discovered by turning the corner of the wall and penetrating its end. The interior presents questions of what is perceived and what is actual. Walls and doors act as transformers, each swing-able to create multiple readings of space. Two modular grids differentiate the public from the private, as does the differing character of the space developed between the floor and ceiling planes. The floor of the public realm yields a stable underfooting, while its ceiling lifts away at an obtuse slant. The roof over the private space remains perfectly horizontal, while the floor drops away at a ramping pitch.

A vast view is revealed from this high perch and the space within merges into all of the place that surrounds.

Dirk Denison
Petersen II Residence, 1993
Bloomfield Hills, Michigan

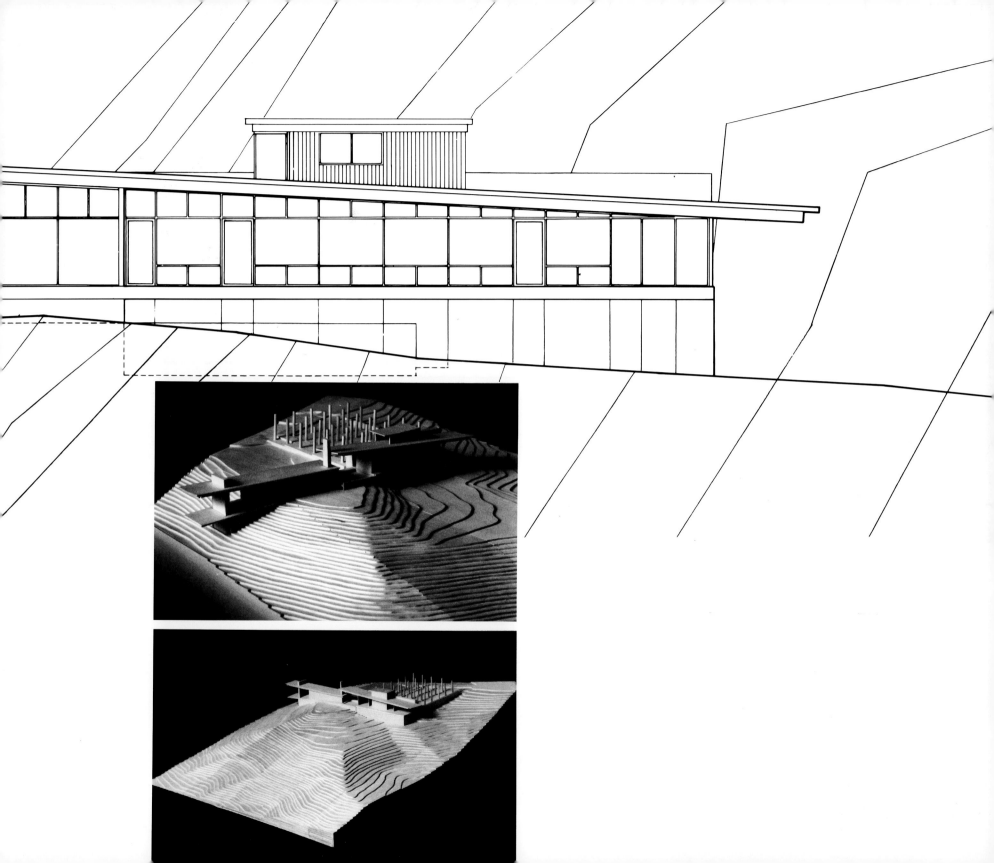

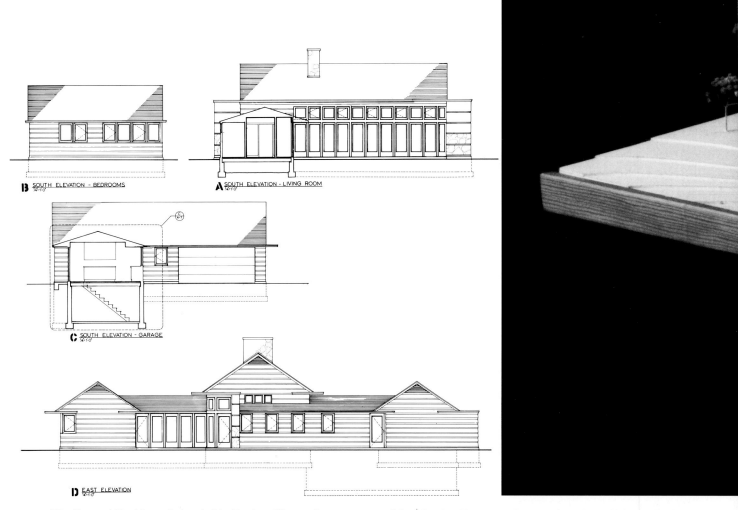

B SOUTH ELEVATION - BEDROOMS
1/4"=1'-0"

A SOUTH ELEVATION - LIVING ROOM
1/4"=1'-0"

C SOUTH ELEVATION - GARAGE
1/4"=1'-0"

D EAST ELEVATION
1/4"=1'-0"

John Eifler
Eifler and Associates
Gasperi Residence, 1992-93
Racine, Wisconsin

The Gasperi Residence is located in Racine, Wisconsin, on 5 acres of farmland, adjacent to the remains of an old barn. Early in the design process the owners expressed a preference for a design which evoked a rural character, comprised of a "collection" of buildings, similar to a typical farm. Building materials such as fieldstone salvaged from an old barn foundation, cedar siding, and large-scale asphalt shingles were used to reinforce this image. The house is designed to take full advantage of sunlight, solar heat, and views of a pond to the north. Heat is provided by means of a radiant hot-water system embedded in a tinted concrete floor. Modest in size, scale, and budget, the Gasperi House represents an honest and straightforward approach to the issue of the modern house which is considered to be appropriate for this day and age.

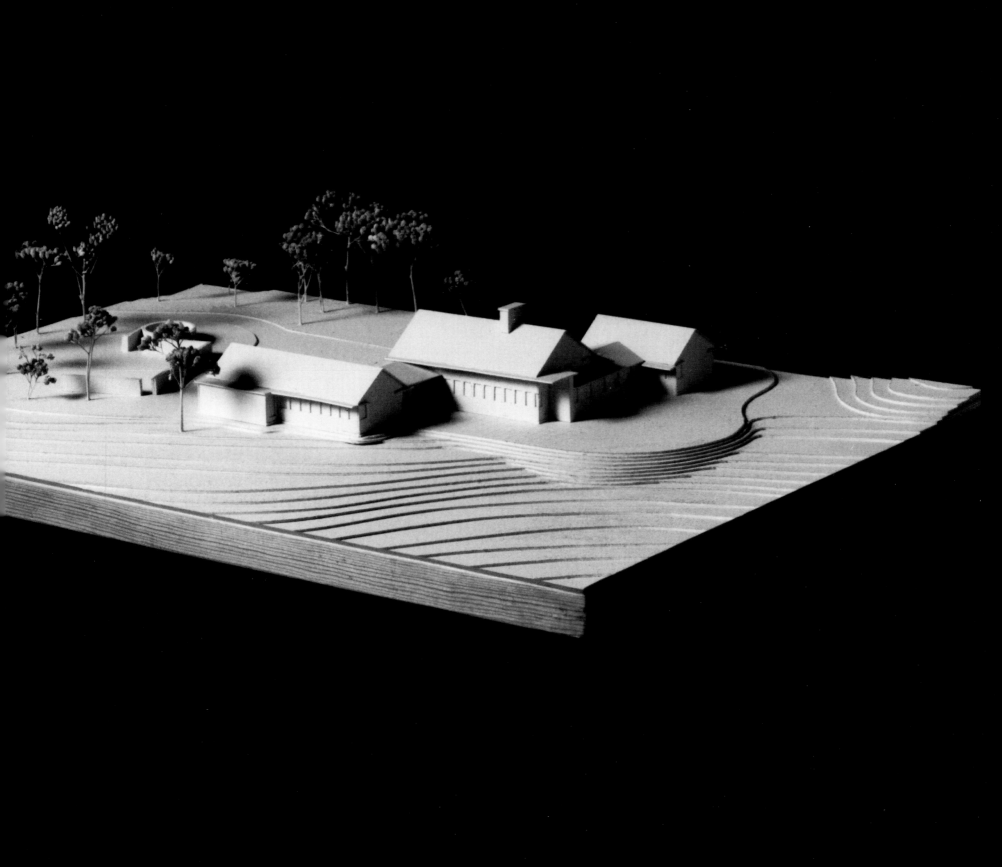

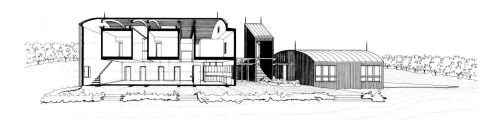

The principal goals of the client in designing a residence were energy conservation, good daylight, and an emphasis on the beauty of the landscape. The clients chose a beautiful site in the Berkshire Hills. The lightly wooded site slopes steeply uphill from a two-lane country road on its southern boundary. A knoll at the north end of the property has impressive views to the south, east, and west. The design goals were achieved by opening the house to the views, admitting solar gain through the extensive use of glass on the south wall, and by berming the house into the south side of the knoll.

The arrival path to the house offers a series of landscape views framed by architectural elements of varying scales. A tall tower, visible from the bottom of the hill, marks the point of entry. The tower appears as a portal when viewed from the guest parking to the north. The house and garage form a wall, allowing entry and framed views only through the tower base. The tightly framed view at the top of the stairs gives way to rather expansive views down the stairs. Once inside, window mullions frame multiple views of the landscape.

The interior spaces help meet the client's energy and daylight goals. The large two-story public room allows views from both floors and can be vented at the top, eliminating the need for air conditioning. Ceiling fans redistribute heated air in winter. Bedrooms are on the south side of the second floor, allowing views and direct solar gain. Bathrooms, offices, and closets occupy a long zone to the north on both floors. These rooms will be temperate year-round due to earth berming, and only those rooms that are in use must be heated in winter.

The technology of the house is designed to maximize energy conversation. In particular, the south facade is a dynamic apparatus for regulating temperature and light. Insulating rolling doors close to contain heat during winter evenings and shed heat during summer days. On winter days, the doors are opened and solar heat is captured in the mass of the masonry floor and water tubes. Solar panels provide domestic hot water year-round. These panels are mounted on the entry tower to prevent shading. Architectural elements are used to meet multiple design goals. For example, the tower serves as a focus from downhill, a portal from the north, and a carrier of solar panels. The interior space offers dramatic views of the landscape, allows natural light to penetrate deeply, and facilitates heating and cooling. Through design synergism, this house realizes the client's hopes.

Douglas Farr and Gwendolyn Conners
Ruff Residence, 1990
Berkshire Hills, Massachusetts

36

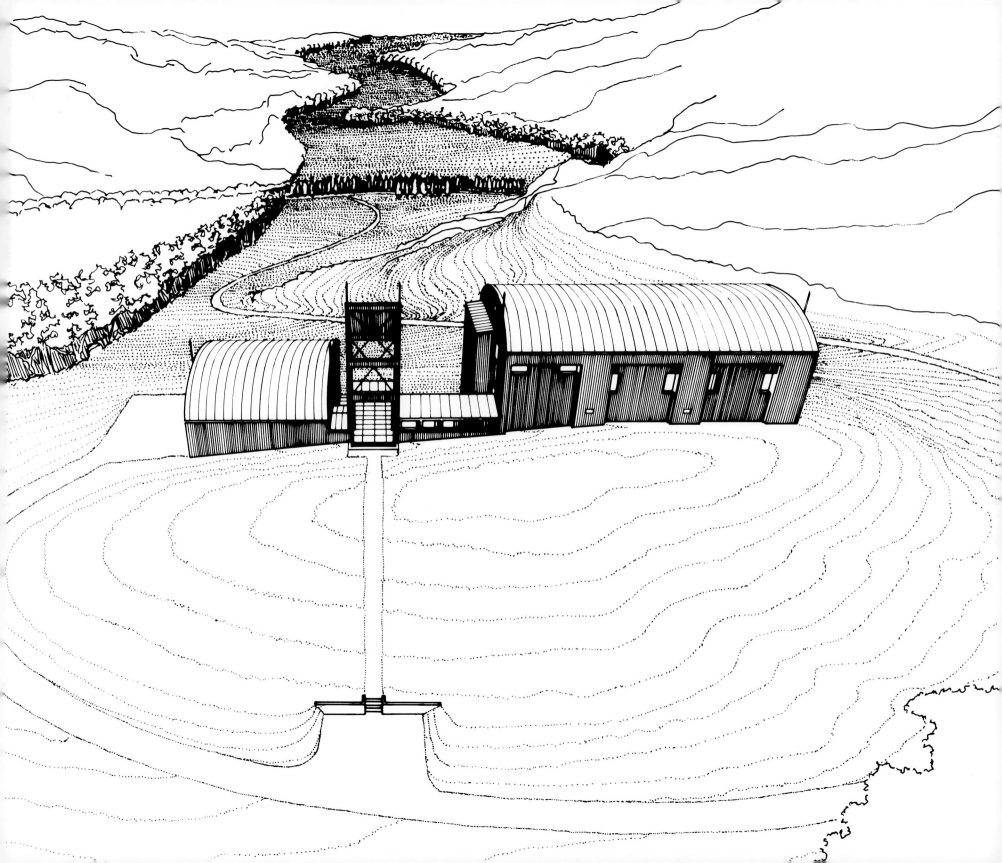

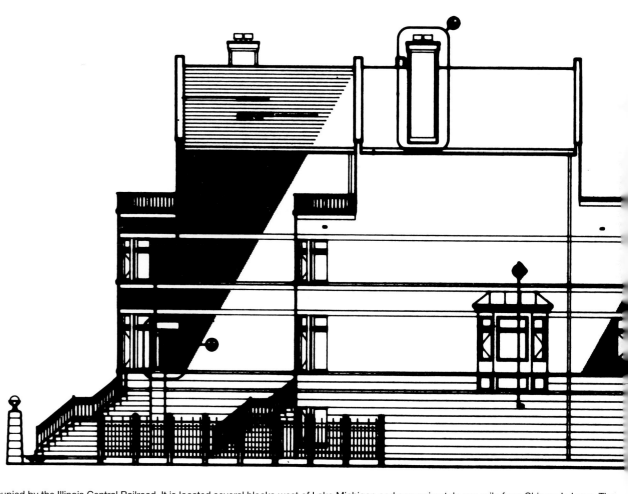

The Central Station Development consists of 72 acres of vacant land formerly occupied by the Illinois Central Railroad. It is located several blocks west of Lake Michigan and approximately one mile from Chicago's Loop. The land has been vacant since the demolition of the Illinois Central Railroad Station in 1974. As the architects for the first townhomes to be built in the development our assignment was to make the residences of Central Station a destination for those seeking quality urban living at a convenient location.

In order to accomplish this goal we felt it essential that the buildings project an image of solidity and permanence. The high density (26 units per acre) mandated by a costly site required townhomes in both three and four-story configurations. We grouped the units into a number of larger buildings, each of which is given individual expression through turreted corners. The various structures are united through the use of common materials (brick and limestone) and imagery.

The individual homes occupy a small footprint and range from 2,123 to 3,671 square feet in size. They are designed to provide for gracious urban living on three or four levels. Wherever possible, front doors face the street across small, fenced yards. Private outdoor space is provided by a third floor roof terrace that also serves as emergency egress. Most plans place the master bedroom suite immediately above the primary living level to minimize routine stair travel for occupants. Each home contains a private garage for one to three cars.

Elements of the Romanesque style were employed to enable us to effectively unite the massive structure and also provide interest through the use of a limited number of significant details. We believe that this robust style conveys the desired connotations of permanence and stability and references a period when the City confronted its problems with confidence and optimism.

We also wished to set a high standard and establish an architectural language of sufficient strength to suggest that future buildings in the development reflect and acknowledge the historical importance of the site as it is developed into the 21st century.

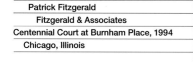

Patrick Fitzgerald
Fitzgerald & Associates
Centennial Court at Burnham Place, 1994
Chicago, Illinois

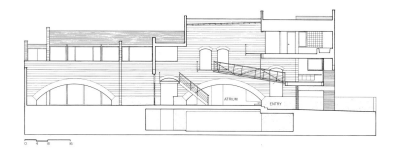

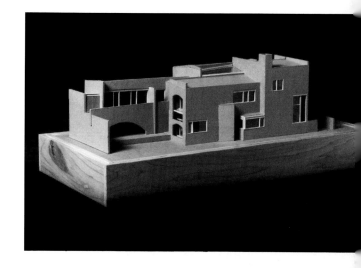

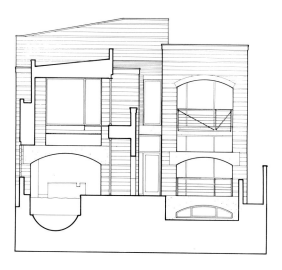
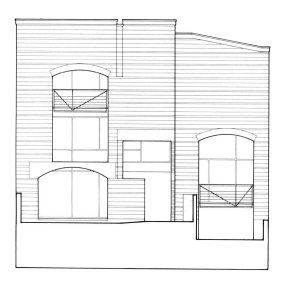

Concrete and block walls overlap and interconnect to form two rectangular structures. The skewed void created between these buildings is enclosed by glass doors and a glass roof. This central atrium leads from the entry through the house to the private garden beyond.

Arches of brick and concrete form a primitive masonry framework that begins to define the interior environment. Glass curtain walls set within this framework provide actual climate control. Interior and exterior spaces become interchangeable. Private interim levels open onto public interior spaces and into walled gardens beyond.

The structures here are reminiscent of the preindustrial-era terra-cotta pot factory that occupied the site until 1987. Timeless engineering principles are reflected in load-bearing walls and simple arches. This structure recreates an aesthetic of necessity which once followed the rail lines and rivers of the "city that works." This manufacturing vernacular relies on simple materials and forms to provide enclosed, climate-controlled spaces for daily living. The nature of these materials, highlighted with the movement of sun and the changing seasons, reinforces our connections to the environment.

Within these walls the whole of the site is transformed into a micro-climate of living, separated from urban threats, climate changes, and the whims of architectural style-makers. We have sought first to create shelter. Next, we have created an oasis for a daily interaction with nature. And, finally, we have sought to provide a home for the soul. The result is an urban villa. A timeless structure to be transformed by the seasons and molded by its inhabitants.

Paul Froncek Architects
Paul Froncek, Chariss McAfee, Catherine
Becker, Craig Griffin, John McCarthy
Lakewood Avenue Residence, 1994
Chicago, Illinois

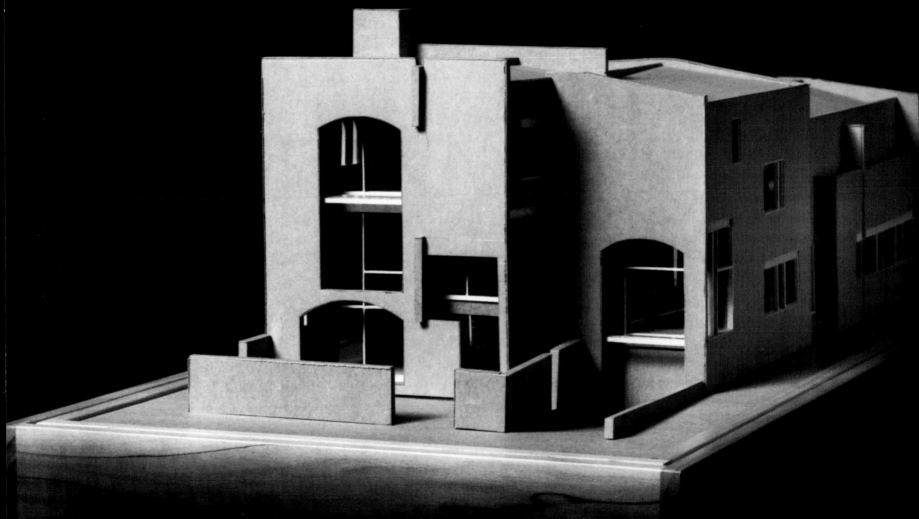

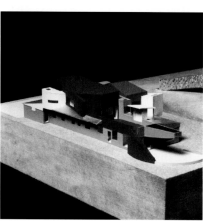

On Domesticity & Dreaming

The four projects presented are all suburban interventions; that is to say, they all represent a practice whereby architecture comes into an existing situation to modify, influence, settle, or hinder, and as such varies between the related and unrelated, the necessary and unnecessary, the relevant as well as the irrelevant. If there is a formula or methodology to this architecture as intervention, it has to do with a close reading of circumstance (inclusive but not limited to "context") and a belief in the undecidability of these circumstances, and therefore of architecture itself. The condition of undecidability has nothing to do with resignation, nor with some completely free play of meaninglessness; on the contrary, the very instability of meaning and our lack of agreement with respect to it is exactly what opens up any design practice to invention. This condition, "neither meaningful or meaningless,"[1] where hierarchical order becomes destabilized, is in fact the very condition whereby inhabitation is allowed, where dreams proliferate, where domesticity is consciously active, participatory, independent, and inventive. According to these qualities, domesticity and dreaming become highly critical aspects of inhabitation; and while this sounds prosaic and poetic enough, it is imperative to completely disagree with the typical advertisements of commerce that promise ever-more-perfect domestic arrangements so-called "dreamhouses." Like all utopias, these are unreal and hence unattainable, having instead the peculiar effect of restricting or silencing anything at all dreamlike.

While the most important function of the house is to shelter dreams, dreams themselves are in fact better left unfinished: "It is better to live in a state of impermanence than in one of finality, for a house that was final, one that stood in symmetrical relation to the house we were born in, would lead to thoughts, serious sad thoughts, and not dreams."[2] Dreams are indexical—they refer to and in effect critique the world. "Dreams are no accomplice of sleep,"[3] and as such are neither lazy nor easy. And if domestication means taming, managing, or making digestible the richness of this "critical dreaming," then comfort is hopelessly confused with dutiful complacency.

Douglas Garofalo

Camouflage House, 92, Derman House, 92-93

Chen House, 93-94, Dub House, 93-94

Burr Ridge, Skokie, Winnetka,

and Highland Park, Illinois

1. J. Kipnis, *A Matter of Respect* (Tokyo: A+U, Jan., 1990).

2. G. Bachelard, *The Poetics of Space* (Boston: Beacon Press, 1969)

3. M. Foucault, *Dream & Existence* (New Jersey: Humanities Press, 1993).

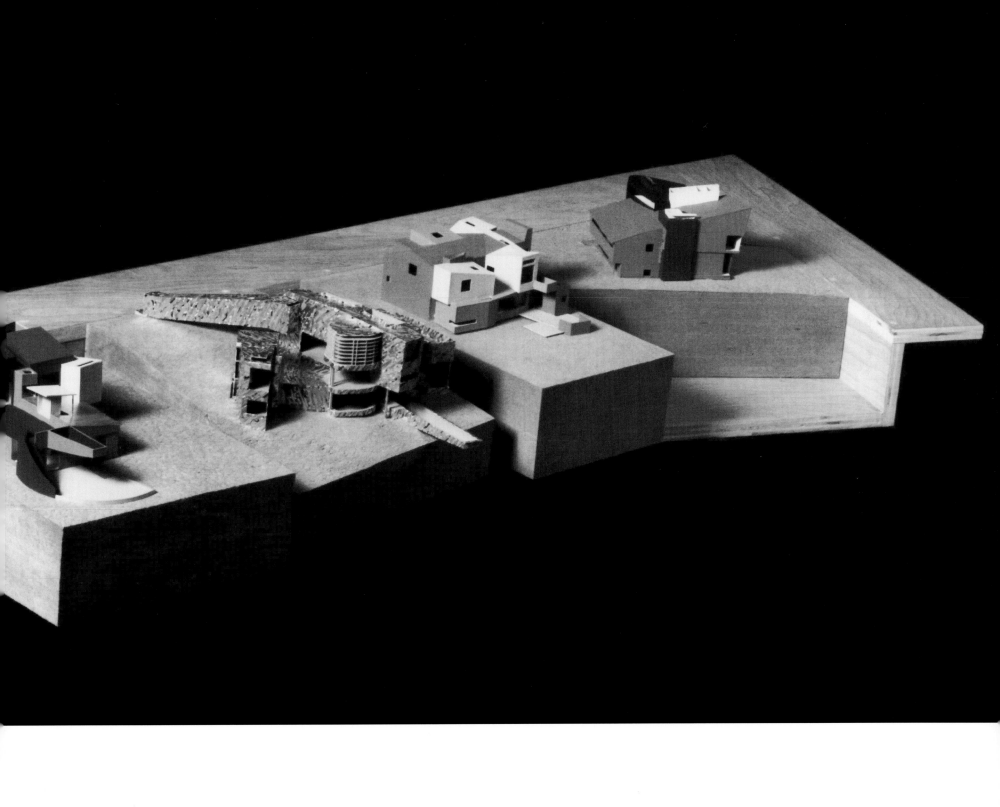

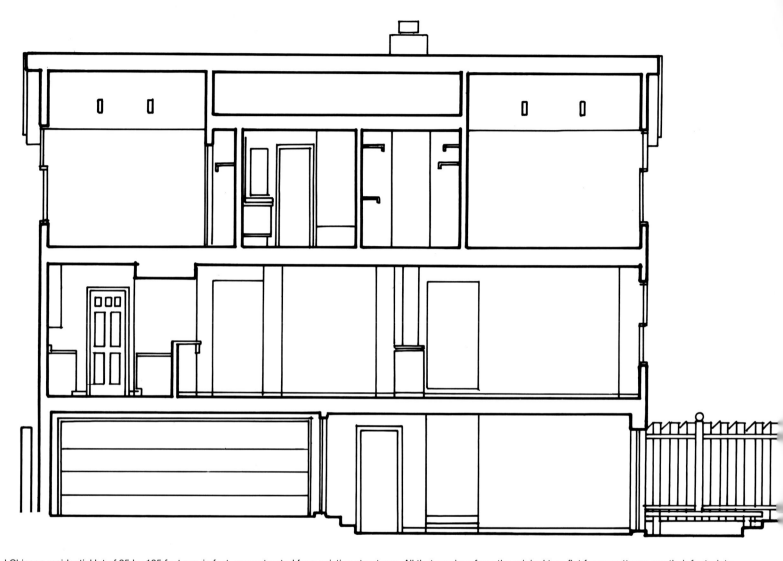

These two houses, built on a single, standard Chicago residential lot of 25 by 125 feet are, in fact, reconstructed from existing structures. All that survives from the original two-flat frame cottages are their footprints, foundations, and portions of their perimeter walls and framing. Each structure was completely rebuilt with all-new interior finishes and a new exterior envelope.

Howe Street was developed in 1888, during the reconstruction boom that occurred in the years following the Great Chicago Fire of 1872, and was named after developer Edward G. Howe. Today, over one hundred years later, a similar construction boom in single-family houses is underway, albeit more costly and architecturally pretentious. On this highly developed street, the old houses, built as quick shelter for the neighborhood's original working-class German inhabitants, have been demolished without a second thought. The new buildings, typically three to four stories, are constructed on single or even multiple lots, with occupied floor space built up to, or in excess of, the zoning allowance. What results is a street that has forgotten itself. The new homes dwarf the survivors and ignore the materials, massing, setbacks, and grammar of the originals.

Accordingly, it was decided to continue with the front-house/coach-house arrangement of the existing structures and thereby reinforce the faded pattern of the street, sidewalk, backyard, and alley. The exterior materials of the new houses are the same as those of one hundred years ago: masonry for the raised basement; clapboard siding for the upper walls; shingles, brackets, and simple window hoods as the only ornamentation; and shingles on simple gabled roofs. The exterior of the Howe Street houses appear to be like thousands of others across the city.

The interiors of both houses, however, are characterized by open plans and abundant natural light. On the main floors, the living and dining rooms and kitchen flow into each other, and are focused around freestanding fireplaces. The second floors have bedrooms at each end flanking central baths and walk-in closets. The ground floor of each building has a family room and a garage. Materials throughout the interiors are simple: painted drywall, white oak floors, cork or linoleum kitchen floors, and granite or marble countertops.

| Laura Hochuli and Philip Hamp |
| Howe Street Houses, 1987/91 |
| Chicago, Illinois |

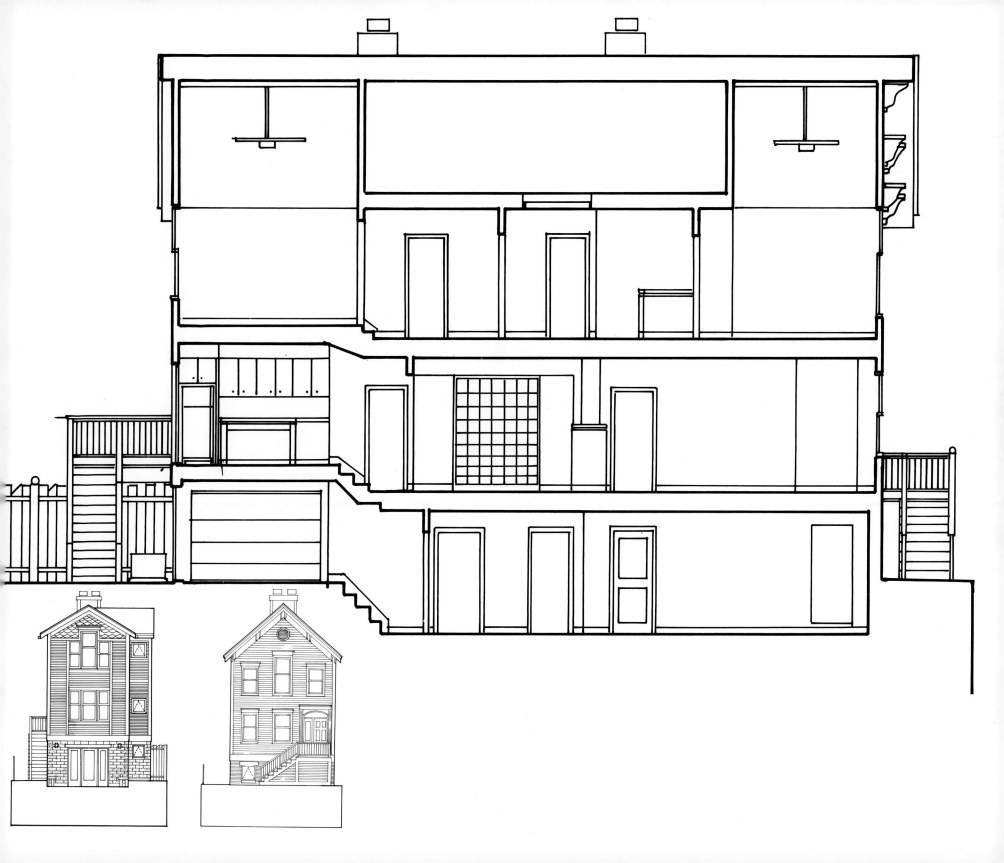

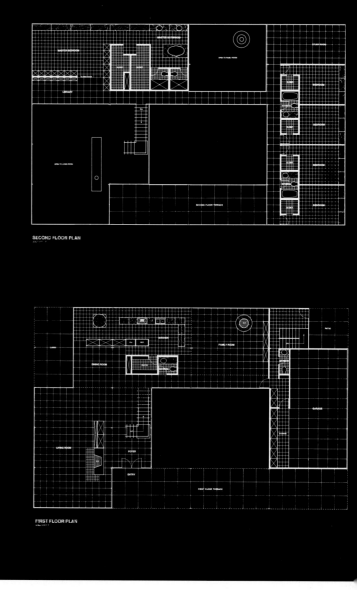

SECOND FLOOR PLAN

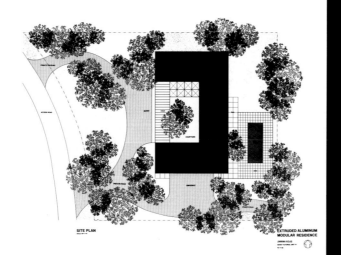

SITE PLAN

EXTRUDED ALUMINUM
MODULAR RESIDENCE

FIRST FLOOR PLAN

This two-story residence includes approximately 6,000 square feet of interior space, 576 square feet of second-floor roof terrace space, and a large courtyard.

The structure consists of seventeen 12-by-24 prefabricated modules, built in a factory and bolted together at the job site. Columns and beams are of extruded aluminum tubes. The curtain wall is a thermally broken integral part of the tubular structure. Virtually all interior components are prefabricated, including plywood floors and medium-density fiber-board partitions.

Each exterior elevation is a response to the open or closed type of space within each house. In other words, the relative opaqueness and transparency of the elevation relates to the function of the space it is enclosing. Exterior materials consist of aluminum, glass, granite, corrugated metal, and concrete aggregate. There is a unity to the diverse composition of each elevation and the materials of which they are composed.

The interior space contains five bedrooms, three and one-half bathrooms, a family room, and a three-car garage at grade level. Except for the garage, which is completely enclosed, the space is mostly open, with living, dining, kitchen, and family rooms flowing from one to another. The second level is more enclosed to provide privacy for bedroom areas.

The industrial techniques of construction within the natural setting of tall shade trees and a gently sloping grade provide a rich dichotomy.

| David Hovey |
| Optima, Inc. |
| Extruded Aluminum Modular |
| Residence, 1991 |
| Protoype |

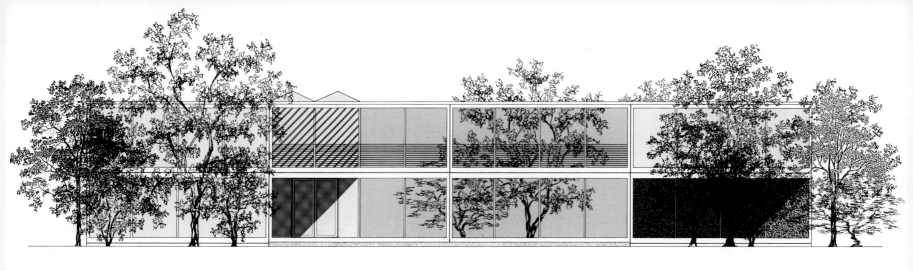

WEST ELEVATION
SCALE: 1/4"= 1'-0"

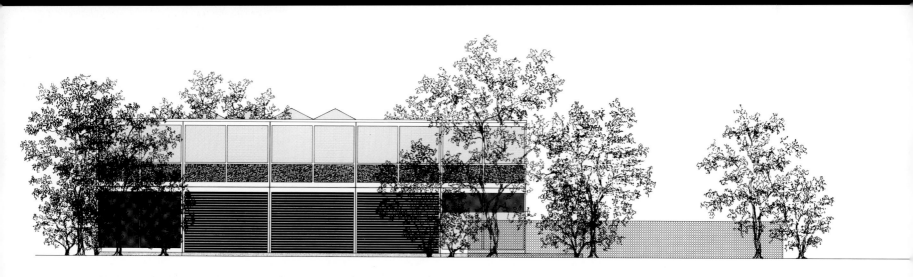

SOUTH ELEVATION
SCALE: 1/4"= 1'- 0"

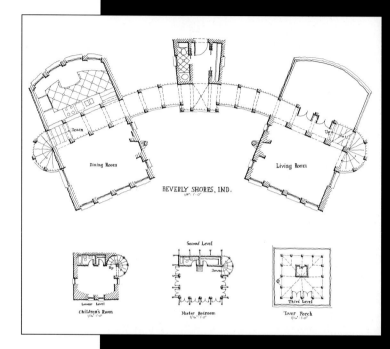

BEVERLY SHORES, IND.

Dining Room

Living Room

Down

Up

Second Level

Children's Room
Lower Level

Master Bedroom

Tower Porch
Third Level

Karen Johnson and Fred Wilson
The Schwab Residence, 1990
Beverly Shores, Indiana

The house is situated on the peak of a 100-foot-high dune approximately 400 feet from Lake Michigan. The tower image allows the owner to elevate the screened-in porch to overlook the treetops to Lake Michigan beyond. The house is entered through a central pavilion which is flanked by a glass-block "spine" which leads to the separate towers. **One tower contains the living room, with the children's bedroom below and the master bedroom above, while the other tower contains the kitchen, dining room, and guest bedroom below.**

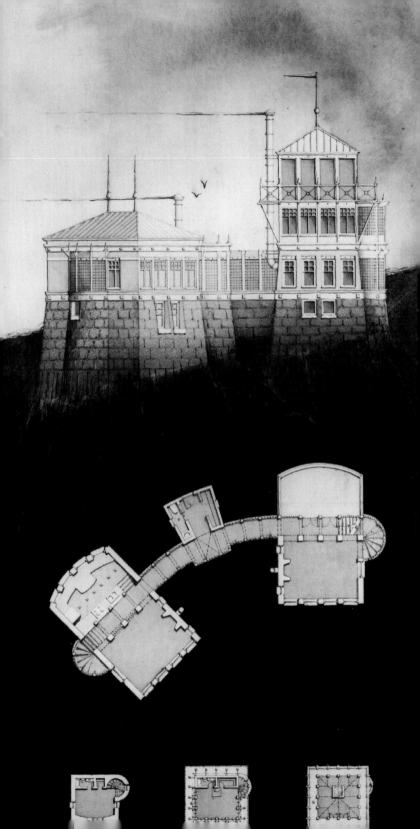

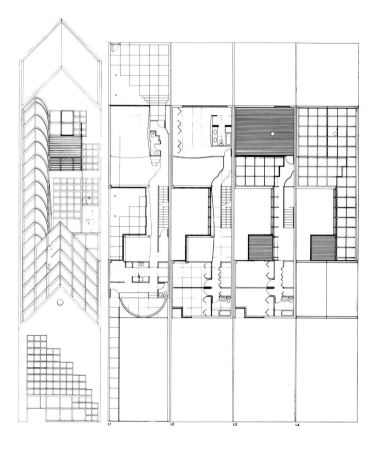

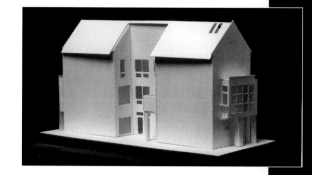

The urban in-fill residence prototype was pursued on a previous commission prior to the Moorehead commission. The long narrow sites required for traditional solutions were recalled to solve the architect's major problem of inadequate and quality fenestration to spaces. Historically, light wells were added to large apartment blocks to achieve minimal standards. This device was used to create spaces—an interior courtyard and balcony—which evoke a sense of place.

The Moorehead Residence sits on a narrow urban lot twenty-five feet wide, located on the Near North Side of Chicago. The neighborhood is composed of two-story masonry structures with English basements. Both new and renovated buildings dominate the adjacent streetscape.

The program calls for a single-family residence to be designed with the capacity to have large family gatherings, with separate spaces for adults and children. In addition, the residence is to have four bedrooms. Due to site narrowness, the program square footage required the floor plan to be developed on three levels. The first level contains the entry foyer, kitchen, breakfast room, family room, powder room, and exercise area. On the middle level is the living room, formal dining area, master bedroom, and master bath. The upper level contains three bedrooms and a bathroom.

Our solution to the program's spatial requirements necessitates the long narrow volume to be formed in a nontraditional manner so that more spaces may have an abundance of natural light. The building is an elongated "C" shape with an interior courtyard. The main public space, the living room, is overscaled by creating a two-story volume. The envelope is a reflection of both the historical and modernist mix. The street facade is a masonry gable with limestone coping. A girded modernist bay window notes the living room, with a single fixed window designated over the entrance below. A solitary piece of glass block is placed above to express the room's volume.

The entrance is framed by two columns at the bay. The base of the building envelope is masonry, alternating bands of split-faced concrete block, and face brick, giving a "base" to the overall composition. The major circulation axis is developed along the northern edge of the building containing stairs and corridors. The rooms are positioned for maximum fenestration, facing south and west.

Philip Craig Johnson and F. Christopher Lee
Prototype Residence
(Moorehead Residence), 1989-91
Chicago, Illinois

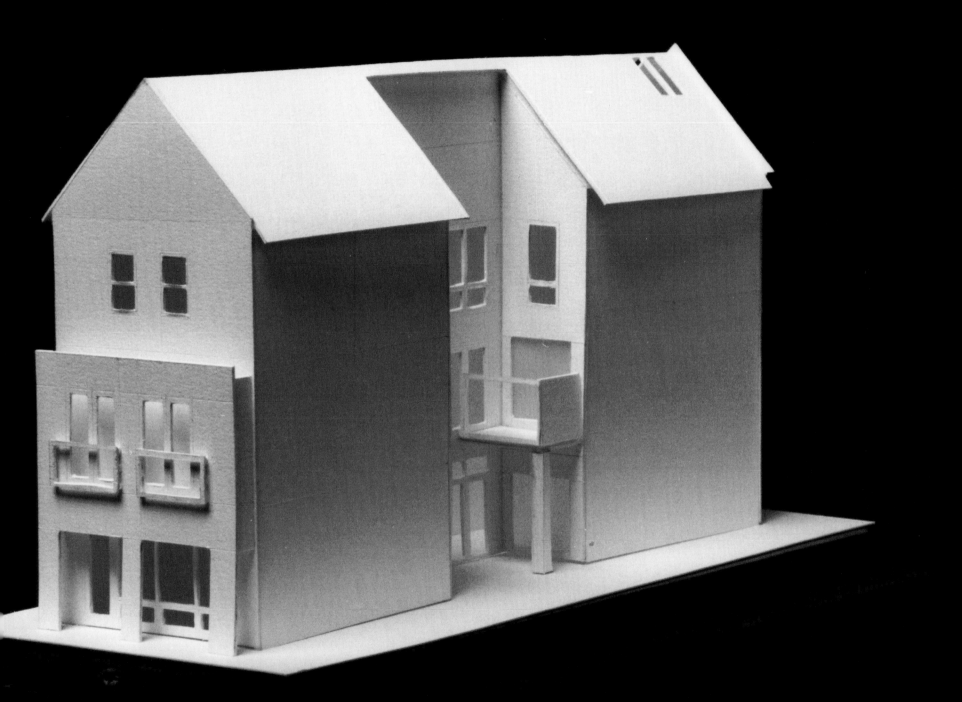

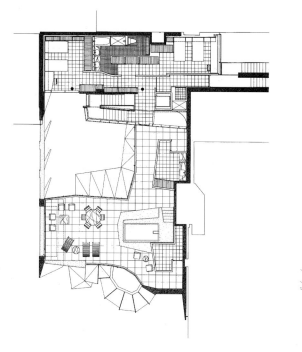

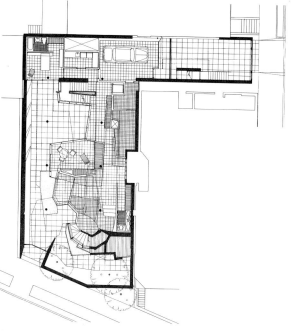

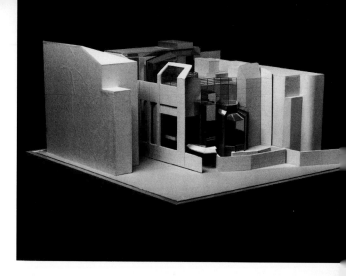

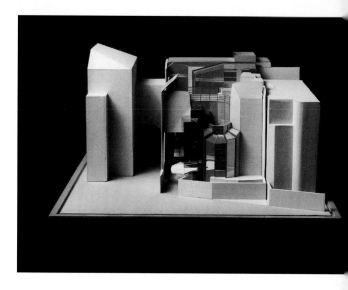

This residence is located on an L-shaped site along the periphery of Lincoln Park, reacting in plan and form to both "front streets." The back of the house responds to the rectangular Chicago grid while a skewed park frontage roadway and the curving forms of the paths and waterways evoke a very different resolution at the front.

Cascading glass and shafts of light, derived from the client's program, permeate the four-story structure to provide an integration of multilevel spaces and related masses. The predominant use of glass as the envelope for the building provides a means of integrating the interior spaces with the lakefront. A sense of intimacy and privacy is achieved through the selective placement of opaque forms and screens. Concrete perimeter walls are bent, tapered, and interrupted, allowing for glass forms to move from the front of the house to develop an interior courtyard. The primary entrance and stairway are very much a result of the same erosive forces which have affected the concrete and terrazzo masses.

Thorough and consistent sensitivity to detailing served to visually integrate often unique applications with more traditional functions of construction materials and methods. The building's curtain-wall presented especially challenging issues. The enclosure varies from a very rigid grid pattern of reflective vision and spandrel glass penetrated by opaque forms, to a baroque composition of faceted glass volumes. Due to economics, it was imperative to manipulate standard curtain wall systems to conform to the more eccentric geometry. This condition is best exemplified in one of the more complicated contexts, the entrance stairway. Three different architectural systems—structure, curtain wall, and lighting—were combined for a delicate and flexible solution. A buttressed structural steel plate was sandwiched by the typical curtain-wall assembly and emphasized by continuous reveals of light, as seen in drawing form. These details assume a tenuous quality which emphasizes the fragile nature of a glass prism.

The success of any specific detail issue was not only determined as its own entity but also as a matter of enhancement to the more general scope of the project. This rationale aided in developing a continuity in vision for the resolution of all issues, from beginning to end.

| Ronald Krueck |
| Krueck & Sexton Architects |
| Private Residence, 1985-86 |
| Chicago, Illinois |

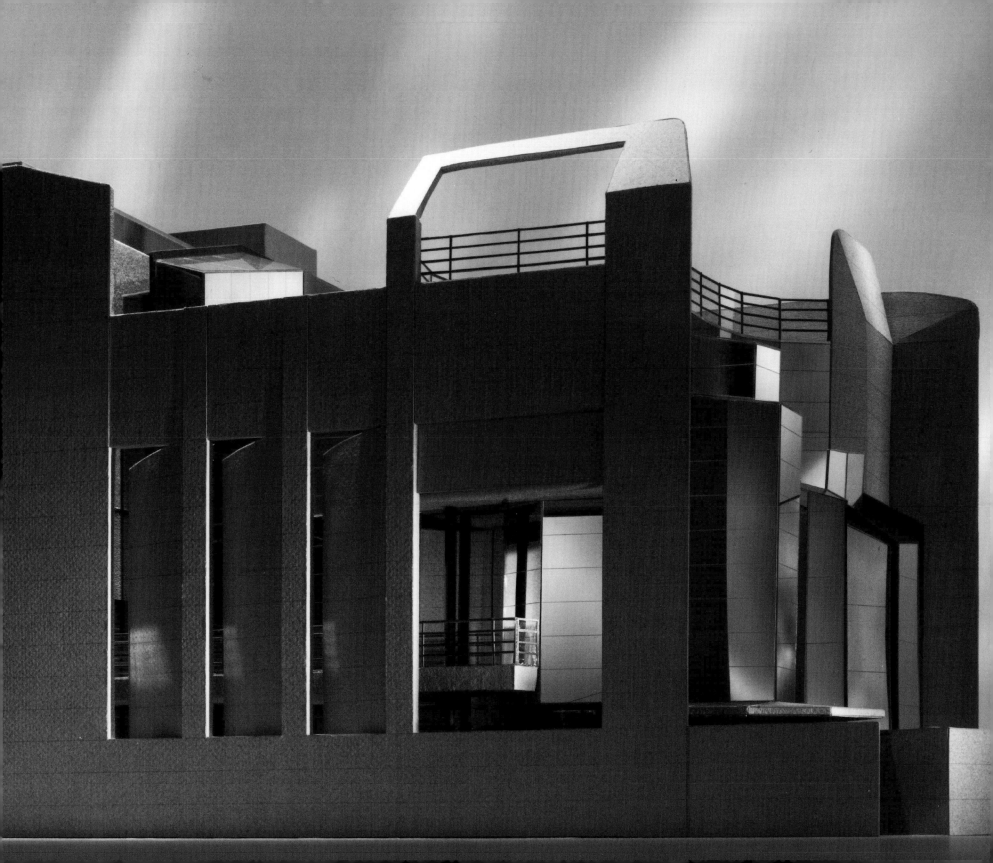

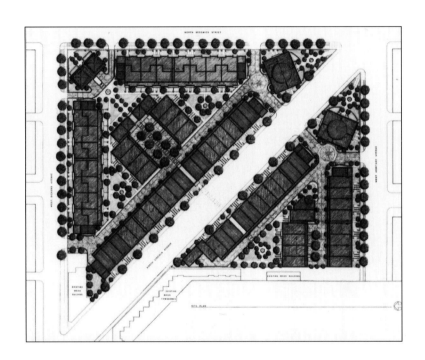

The new townhouse project, The Pointe at Lincoln Park, is being developed on two triangular sites bisected by Lincoln Avenue. The site previously was occupied by a hospital which several years ago decided to divest itself this property and return it to the residential sector. Numerous meetings with concerned community organizations led to a site-development plan consisting of low-rise townhouses, a solution endorsed by the community. The appearance of the townhouses evolved, again, through these meetings to ensure construction that was consistent with the surrounding neighborhood. Guidelines addressing building materials, landscaping, lighting, fencing, and parking were an outcome of the community participation process.

The two sites total approximately five acres and will be improved with 154 townhouse units; the eastern site of three and one-third acres will receive 98 units; the western site of one and three-quarter acres, 56 units. The site development, fostered by two triangular parcels, allowed the placement of major building elements at the southern apex of the parcels. These buildings create a monumental gateway to the residential renaissance of Lincoln Avenue.

The two parcels are visually connected to one another by a continuous arcade or walkway system that bifurcates the project and allows one to walk unimpeded directly through the various buildings. Building location follows the street pattern, thereby continuing the prevailing housing placement. This allows unit entries to relate to the streetscape and places parking on the site interior, removed from street view. Furthermore, the building placement creates interior park clusters affording identifiable open space for residents' use.

The Pointe at Lincoln Park is a major residential undertaking which at its completion will enhance Lincoln Park and continue the strong sense of neighborhood exhibited by its citizens.

Roy H. Kruse & Associates, Ltd.
Roy H. Kruse, Timothy Deutsch, John Keating,
Christopher Munro, Craig Newman
The Pointe at Lincoln Park, 1994
Chicago, Illinois

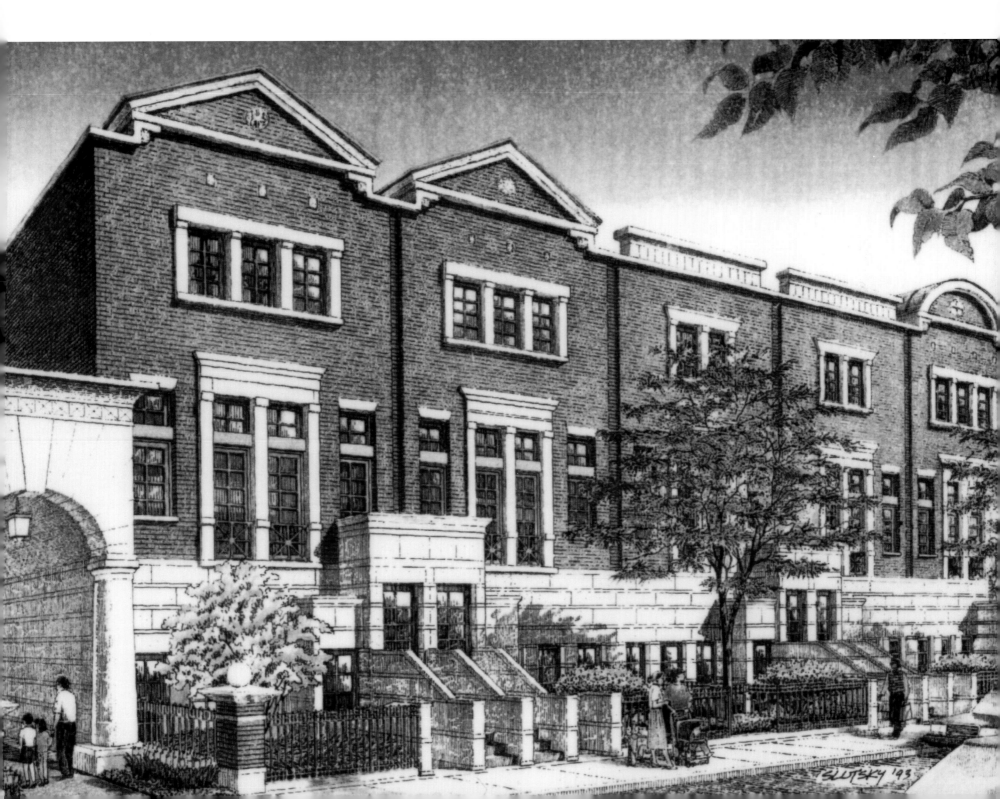

Our clients have been spending vacation time at Beverly Shores for many years before buying a four-lot parcel of land on the third dune back from Lake Michigan. The property rises sharply about twenty-five feet from the road on a north slope densely covered with large pin oak, beech, and birch trees and a variety of smaller brush. There is an eight-inch layer of composted leaves and branches covering the site that support a wide variety of vines, flowers, and mosses.

The program called for a weekend house with accommodations for parents, one child, guests/grandparents, living/dining/cooking, and a reading/garden/sun room all packed into roughly 1600 square feet. We wanted to design a house that was a direct response to the site as well as one consistent with the vernacular of the area. A natural roadbed traverses the site and then cuts back up to a slight clearing at the top of the hill. The house sits in a natural clearing that straddles the ridge at the high point of the site and becomes a natural extension of the access, open space, and views.

The central focus of the plan is a large fireplace construction that divides the two-story living room from the more intimate one-story dining/kitchen area. The roots are simple sheds mimicking the upward slope of the property. The shape and location of the windows are set to frame views, provide cross ventilation, and capture available light.

Floors and windows are pine, and bookshelves define functional separations. The simplicity of the construction, openness of the plan, and intimacy of the space characterize the life-style and aesthetic of the Beverly Shores community.

| Peter Landon |
| Landon Architects, Ltd. |
| Howell Residence, 1993-94 |
| Beverly Shores, Michigan |

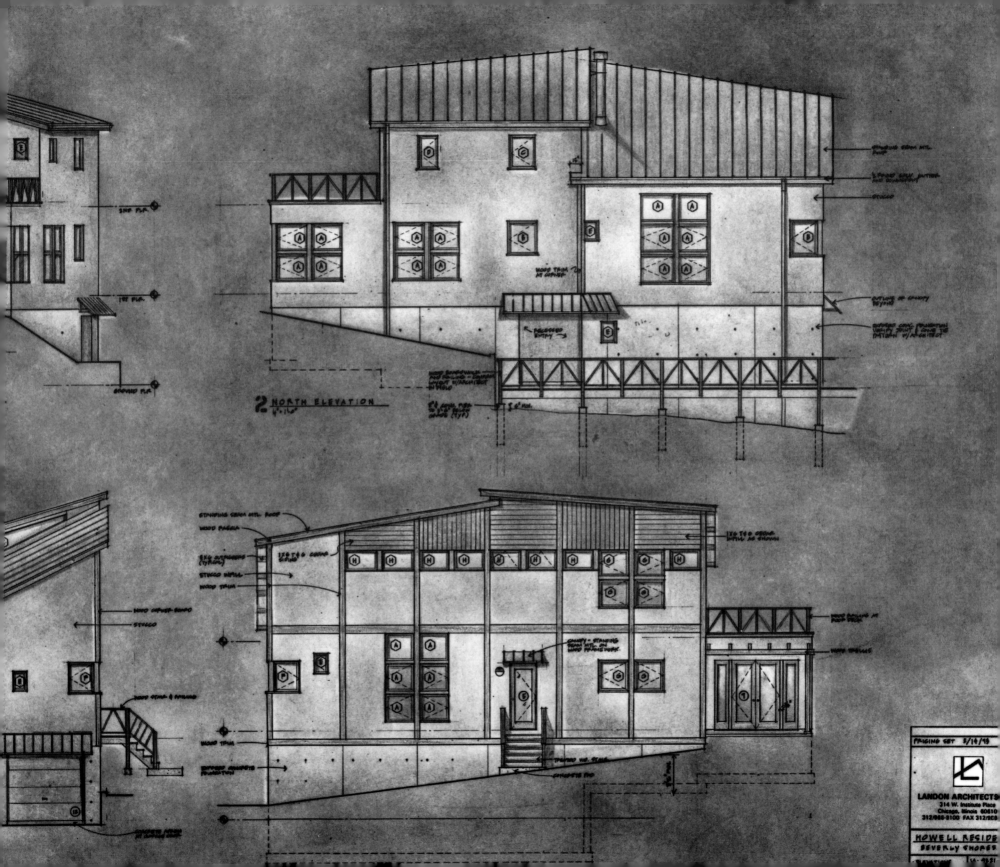

2 NORTH ELEVATION

LANDON ARCHITECTS
314 W. Institute Place
Chicago, Illinois 60610
312/888-8100 FAX 312/888

HOWELL RESIDE
BEVERLY SHORES

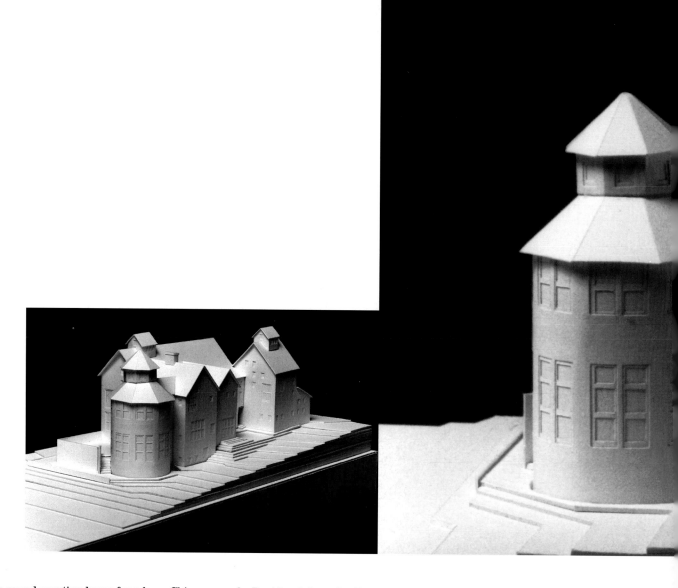

This project is a 4,000 square foot year-round vacation home for a busy Chicago couple, David and Jacquine Doerge, and their small children.

The owners requested a fun, informal home with a "great deal of style" that would recall images of midwestern barns. The resulting design is a series of interesting, gabled two-story structures clad with vertical wood siding. Overlaid is a grid of tiny barn-type window openings which capture light, frame views, and disrupt one's perception of the house's scale, as though the house was a big playhouse.

A small cottage existed on the site, and the family had already vacationed there for long enough appreciate the long sloping lawn; the lake view and accessiblity; the view of farms across the street to the north; and a lovely deck that Jacquine's father had built on the downward, lake side of the was cramped, and so the program for the new house called for bedrooms for gathering and socializing; a big-screen TV; storage space for windsurfers, a snowmobile, and cars; an exercise room to accommodate large pieces of equipment; and a very private and beautiful space to get away from it all.

The new house was partially sited on the foundations and basement of the old cottage, which on the high part of the site away from the line of houses located along the lake front, allowed for open views east and west and preserved the long sloping lawn.

The interior organization of the house is somewhat linear. The garage shields the house from the street and the main living areas are clustered toward the lake. All rooms were designed volumetrically, and the living areas are not only rooms that open to each other both horizontally and vertically but also interlock spatially.

A semi-detached, octagonal, screened porch on two levels allows additional living and sleeping areas, lake views, and summer breezes. At the other end of the house a tall peaked-ceiling above the garage allows for solitude and quiet views of farmland.

| Tannys Langdon |
| Deorge Residence, 1991 |
| Delavan, Wisconsin |

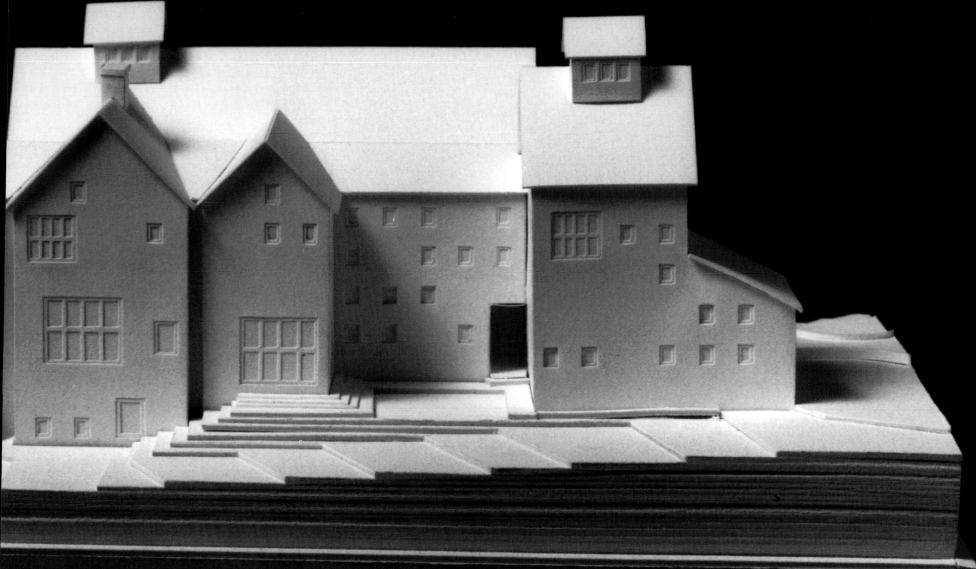

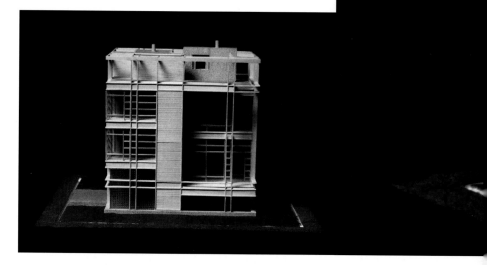

The Devon House's white frame and strict geometry stand in deliberate contrast to its rural Michigan setting. The house is on a slight hill overlooking an emerging hardwood forest to the south and a mature evergreen forest to the north. The house is a perfect forty-two-foot cube with an inventive plan that emphasizes the volumetric possibilities. The structure is three stories tall, but guest bedrooms are set at half-story levels for privacy and economy of space, creating staggering interior spaces. There are other level changes as well. The living room, which is two stories high, is set three steps below the dining room and kitchen. The house's complex plan is faithfully expressed in elevation, creating rich Mondrian-like patterns and rhythms articulated in the exposed frame, clapboard siding, glass block, and custom windows.

Teak decks wrap the corners at some levels and are contained within the building grid by the wood frame. The top of the house is given over to a sun deck in the same material.

| Dirk Lohan |
| Lohan Associates |
| Devon House, 1992 |
| Ada, Michigan |

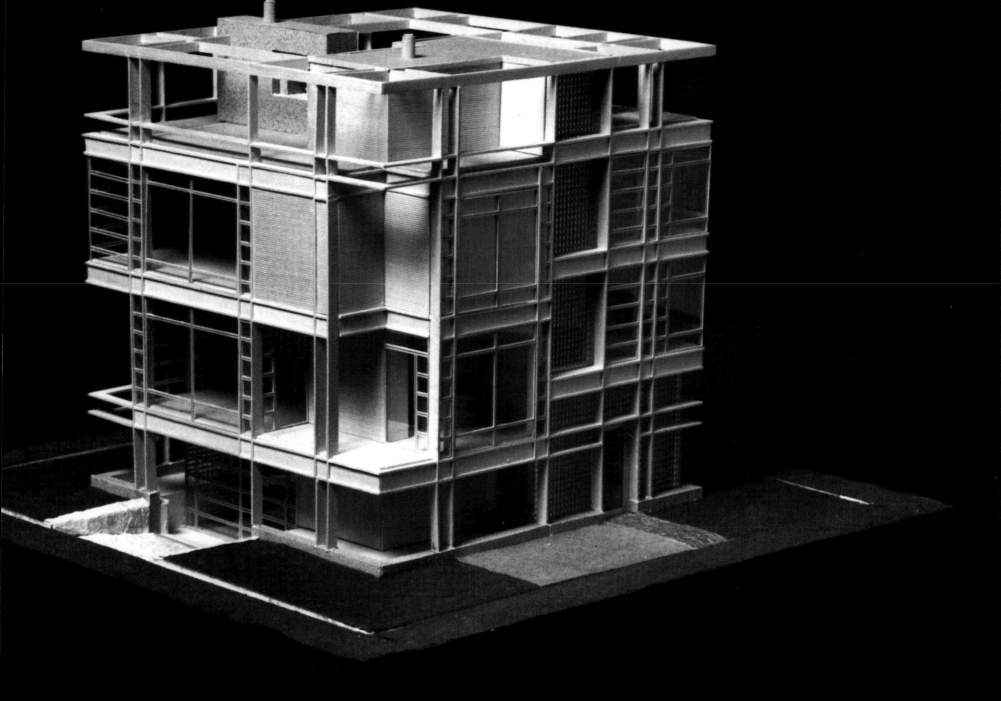

Michael Lustig

Michael Lustig & Associates

Nie Residence, 1994

Sun Valley, Idaho

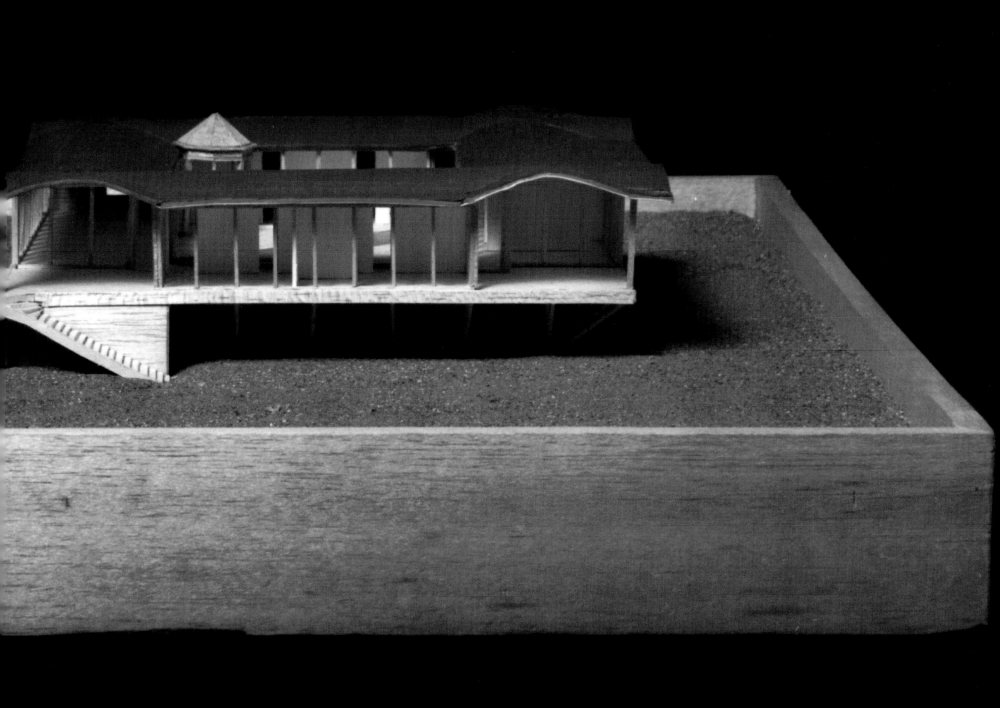

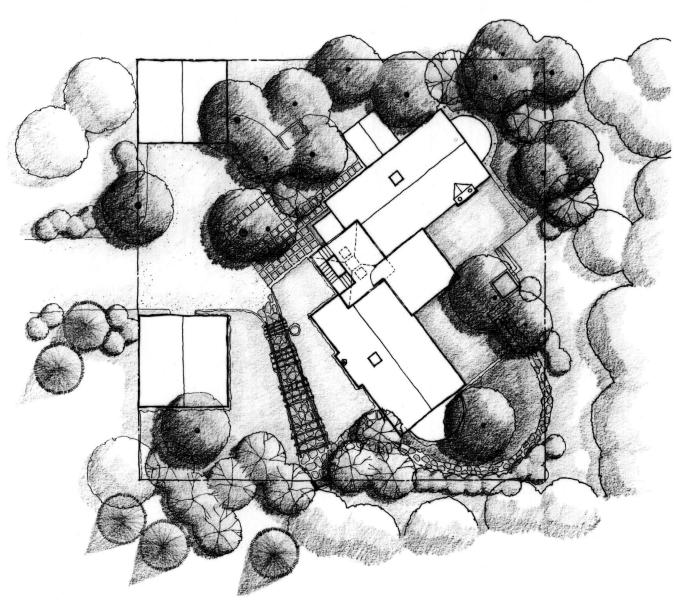

The design concept behind this residence evolved from the interactive process between the architects and the clients, which is an integral part of our design philosophy. In this case, however, the clients lived halfway around the world, so all the drawings and communications had to be self-explanatory. For this reason we developed a typology of schematic residential layouts, including longitudinal/rectilinear, courtyard, box house, and individual and interlocking volumes, all adapted to the specific site. Each house type and the resulting interior spaces inherently carried certain aesthetic and life-style implications. After reviewing each of them, the clients chose to develop the concept of two interlocking rectilinear volumes joined at the pivot point with a tower.

This emphasis on interaction in the conceptual stage is echoed by our "collage" approach in the development of every detail adding up to the overall appearance of the structure. Our tendency (repeated throughout our work since we formed partnership in 1979) is to use traditional materials in a modernist collage of volumes and planes. In this Michigan residence, the use of cedar shingles, clapboard, and color on the exterior are typical of the local housing, although the actual composition and intensity of these elements are not. Window size and location are also distinctly modernist, although in many places the symmetry and rhythm could be interpreted as traditional. The main interior spaces flow uninterrupted by fully enclosing walls, but retain a sense of roomlike volumes, again both modernist and traditional at the same time.

Our metaphor of architecture as collage can be applied to every aspect of the process and product. The Glenn House is a collage of our approach as architects combined with the clients' attitudes toward and associations with houses, expressed as a composition of spaces and materials. At this "turn-of-the-century" juncture, we reject the pressure of the necessity of a constantly changing avant-garde, which often only results in forced complexity. We celebrate, instead, the accumulation of knowledge—both inherent and learned, practical and theoretical—that allows us to freely create something new and different from all that has been built and thought before.

James Mastro and Claudia Skylar
Glenn House, 1993
New Buffalo, Michigan

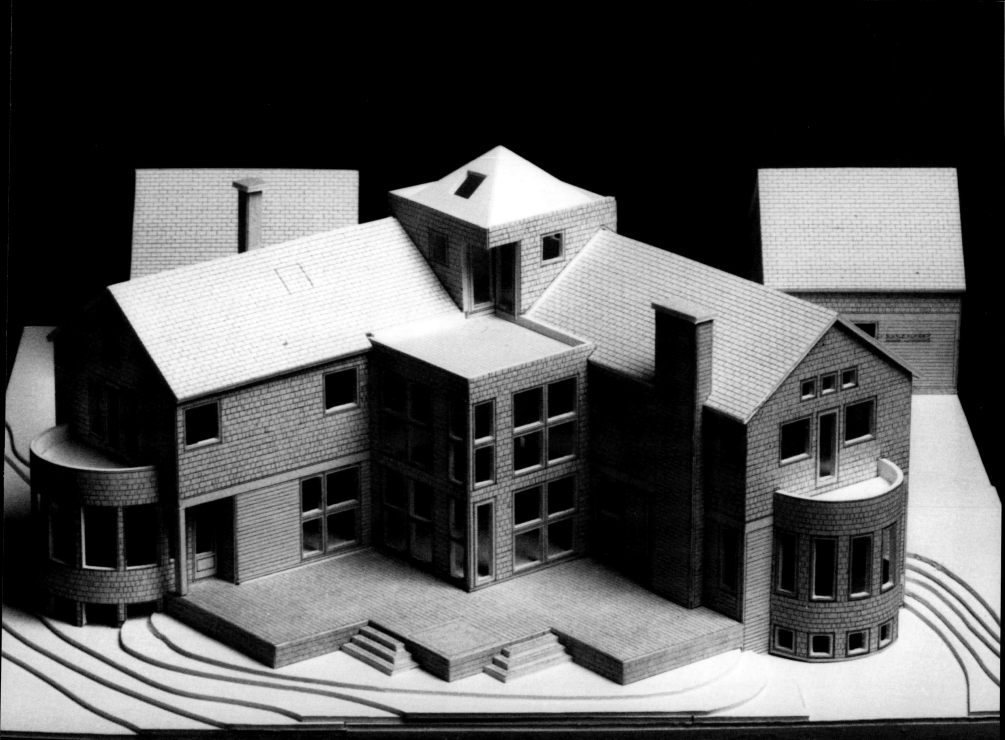

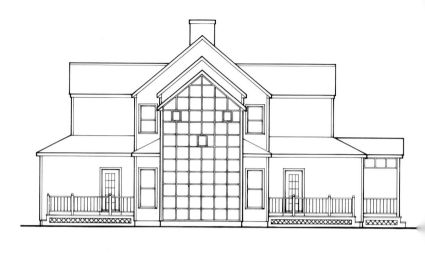

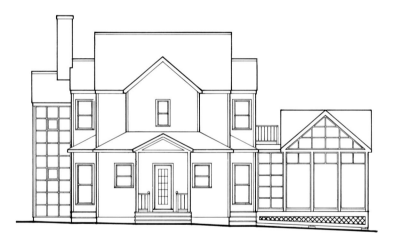

Sited in the forested dunes that define Lake Michigan's eastern shore, this 2200-square-foot country house, home to a family of four, joins a long line of midwestern ancestors in celebrating life in the country. What links it stylistically to its predecessors in other centuries is a certain formality of plan and composition, an austerity of form rooted in function.

Simple in form but complex in meaning, it uses the same familiar architectural vocabulary —the gable as old as the pyramids, the classical hip, the cube stacked conventionally and clad in clapboard punctured by double hung windows —to speak a language that has evolved through time and tells the age old story of the evolution of shelter, but in so doing crafts its own chapter by reassembling and reproportioning common components to resolve its own contemporary criteria. The formal order of the facade finds kinship in the form of the plan as the spatial sequences unfold axially from the entry porch towards the first cross axial corridor that links kitchen and bath. Glass doors terminate this axis physically at either end but visually it proceeds infinitely into the landscape. The second cross axis is the litera and figural center of the home — the place where the family gathers together to share the primordial warmth of the fire at one end and to break bread at the other. The children's quarters open directly off the family headquarters and set up two final axes as windows aligned with doorways continue the procession into nature. Encircling the fireplace, the stairway rises up to the parent's quarters above — a place of study and repose for two professors. Each member of this modern family has their own private place — each child their own deck, each parent their own desk and a shared outdoor deck perched atop the grided "reveal" that visually separates indoor house from outdoor house. The screened in porch has become a separate structure, stressing the importance of leisurely time spent in nature. It's a transparent room extending family life into the natural world.

The grid is also used to encase the stair tower. The second element that is adjunct to the clapboard clad cruciform core of the primary structure, the grid also connotes measurement, a method of establishing order and scale, and thus a certain tranquility that evolves from the resolution of spatial relationships in a harmonious fashion. The form of this house is influenced by precedent but is not bound by it. It refers to the past but takes its place in the present.

| Margaret McCurry |
| Tigerman McCurry |
| Private Residence, 1993-94 |
| Michigan |

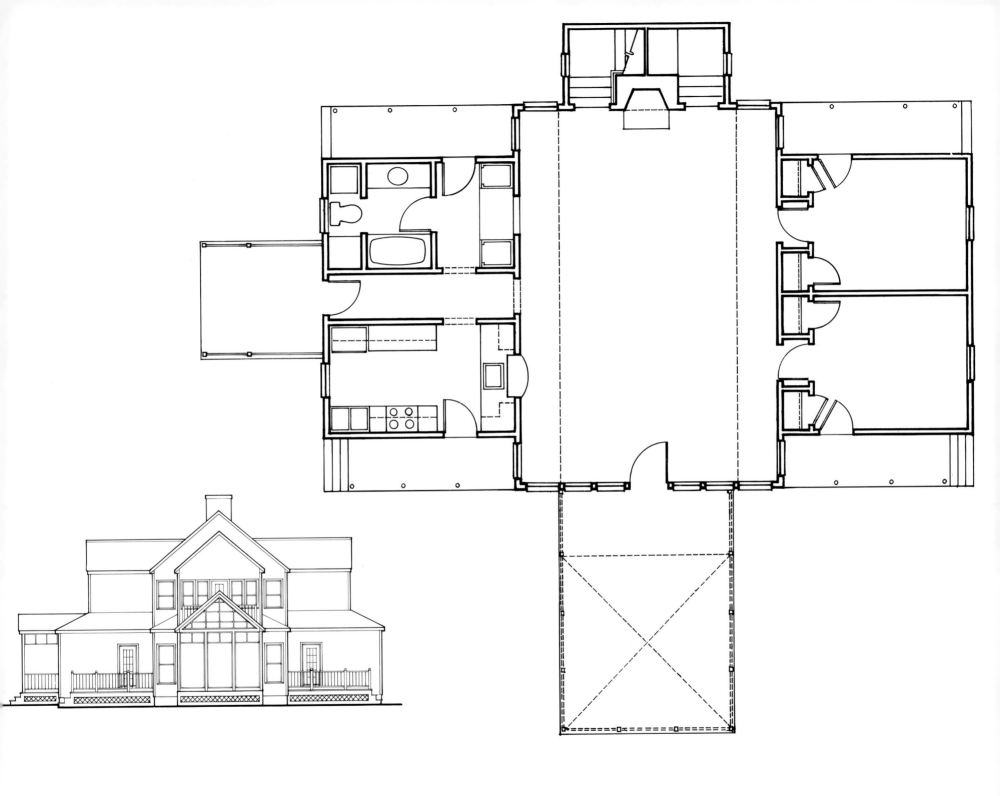

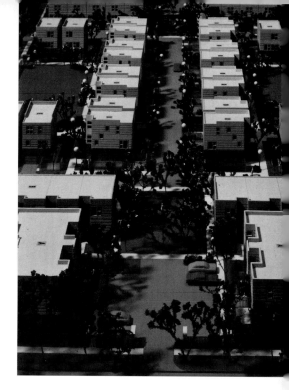

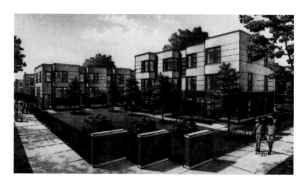

The Master Plan comprises a 55-acre site located five miles west of the Chicago Loop and two blocks south of the Eisenhower Expressway. It was originally the home of Sears, Roebuck & Company's World Headquarters, its catalogue warehouse facility, All State Insurance Company, and related buildings. Currently, about one-half of the site contains the existing Sears, Roebuck & Company buildings. The other half of the site is vacant and was originally used as employee parking lots. Our plan suggests that five of the existing buildings will be used for future institutional or commercial uses. Of the total site area, thirteen and three-quarter acres is targeted for institutional or commercial uses and the existing park. The remaining forty-one and one-quarter acres is to be developed for new family housing units.

The Master Plan calls for demolition of most of the Catalogue Building. The first bay west of Homan and the tower of the historic 1905 structure will be rehabilitated into a community center for the development. The plan calls for the redeveloped structure to contain retail/office space and a day-care center. The tower will be renovated for possible community uses. This structure will provide a focus for community activity and services, while continuing as a symbol of the neighborhood.

Respecting the city's grid and its infrastructure, the Master Plan is designed to cluster the units around public and private landscaped parks. This allows each unit to have views and access to the parks and gardens, thus creating an enclave of landscaped "safe" parks. The plan provides a variety of park locations. A street intersects the parks to form forecourts for the housing units. When they straddle the streets at mid-block they offer relief from the typical city row of similar facades. Where they occur within the block interior, these private areas can be play areas or passive neighborhood parks. We believe these shared spaces, with the proper landscaping and maintenance, lighting, and fencing materials, will enhance the environment and help to create pride in the neighborhood.

It is proposed that Arthington Street stay open to two-way traffic so that it will become the focus of the development, with its new housing and parks straddling the street. The arrangement of parks and housing units allows for approximately seventy-five housing units per block or a density of approximately twenty units to the acre.

The housing is designed to provide a variety of rental and for-sale units, which range from 780-square-foot two-bedroom flats to 1,740-square foot three-bedroom townhouse units. The units and the Master Plan are designed to allow maximum flexibility and interchangability in order to respond to the needs of the marketplace. This project is a joint venture between the original owner, Sears, Roebuck and Company, and the developer, The Shaw Company.

James Nagle
Nagle, Hartray & Associates, Ltd.
Homan Square, 1994
Chicago, Illinois

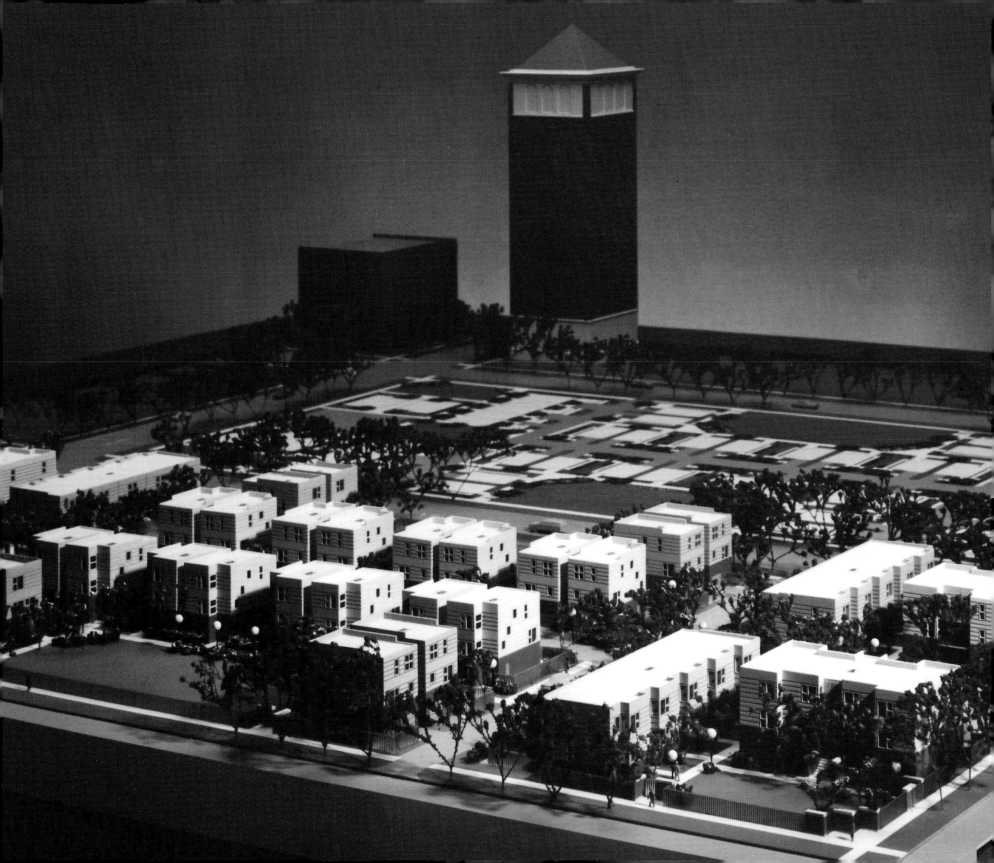

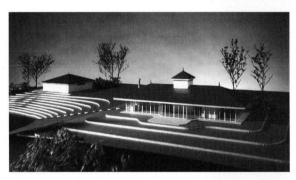

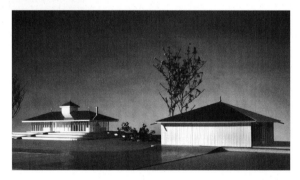

Located on a former farm, this project is sited near a wooded area on the rear portion of a 110-acre parcel.

An old, existing farmhouse and barn provide a "gateway" for a new road to reach the project site.

The residence will serve a couple seeking views to all directions in this remote setting, and this provoked an open-plan concept that was taken to its ultimate form: no partitions will engage the outside wall. Two freestanding interior elements will provide an enclosed bath and the background for an open kitchen. Except for the entrance door, the entire exterior wall system will consist of sliding French doors with high-performance glazing. The roof structure will be of standard steel pipes with an exposed wood roof decking between the pipes. Metal roofing reminiscent of old farm structures will provide the exterior cladding. Precast concrete slabs will be used as the floor finish. Rainwater will be collected at the exterior roof edges via a stone-filled perimeter ground trench and then to a cascade flume to the pond below.

The nearby ancillary building will contain a two-bedroom guest house, garage, and utility area. A matching metal roof will cover a standard, wood-framed roof structure.

| Michael Pado |
| Cottam Farm, 1993 |
| Three Oaks, Michigan |

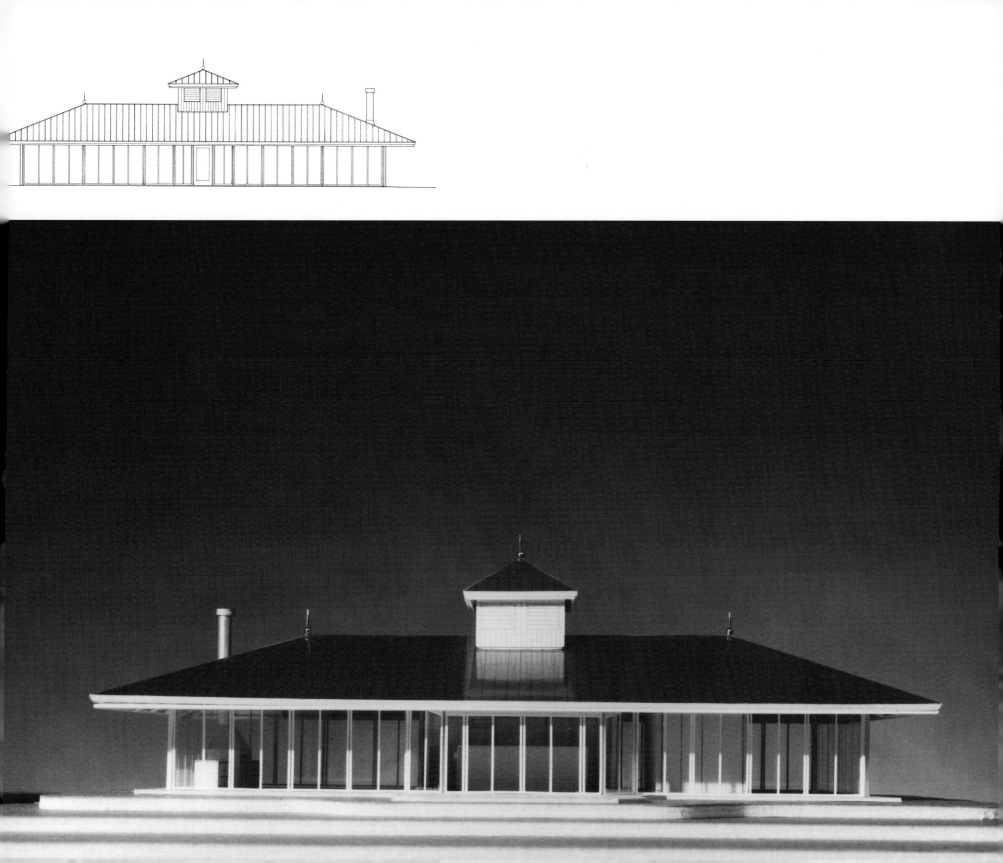

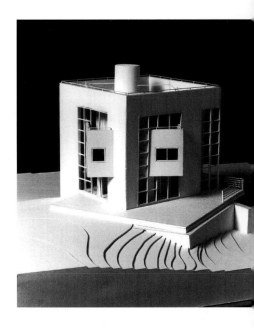

| George Pappageorge |
| Pappageorge Haymes Ltd. |
| Nemickas Residence, 1992 |
| Lot 21, Eiffel Tower Bluff |
| Grand Beach, Michigan |

Taking advantage of the view of and from the southern tip of Lake Michigan, this 3,500-square-foot vacation residence fulfills the client's desire for a modernis tree house for grown-ups. The main volume of the home is a 36-foot cube bermed into a hillside amount progressively larger plans of a parking area and exterior deck. Within this simplistic geometry decreasing rectilinear masses are playfully arranged, one per floor, to house internally focused functions. Seemingly anchored only by a cylindrical stair structure, the sleeping level rotates out of the main volume. Appearing to float, it concurrently defines formal functions of the first floor and more private areas to the loft.

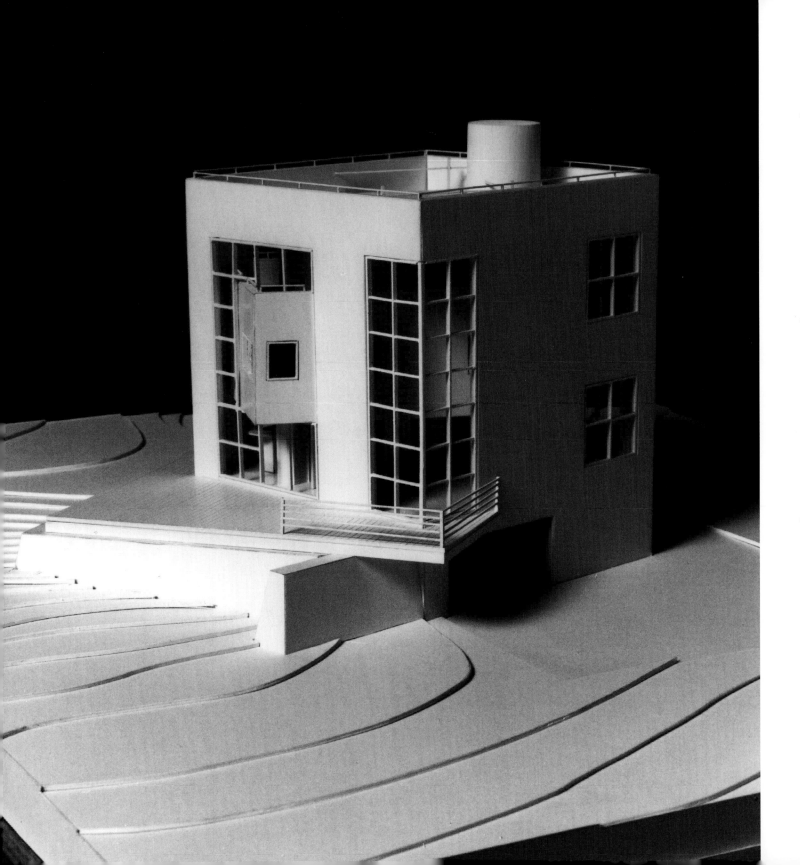

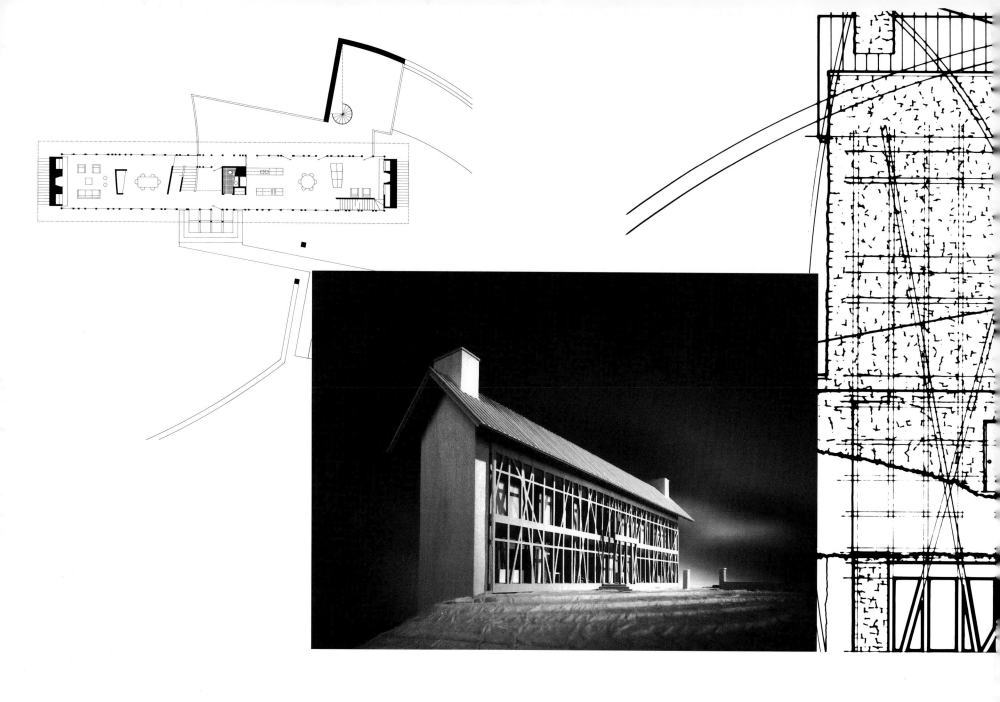

Planned in a new development in an expanding suburb, this house, designed for Pacific-Sakata Corporation, seeks to dispel common notions of the suburban residence. If any preconceived ideas of form and presence exist in this building, they might constitute a return to simple and unpretentious agrarian structures which were once the norm in the area and are now virtually extinct.

The linear structure of steel and glass has formal antecedents in longhouses built of pole frames by the Miami Indians, who lived in the region in the late-seventeenth century. Because of the narrowness and transparency of the structure, as the visitor passes by the two long steel and glass walls shift in relation to each other, making this house literally a window to (and of) the trees.

Freestanding stone walls over the sunken garage to the east provide privacy from the neighbor to the east as well as framing views down the valley to the north.

| Frederick Phillips |
| Frederick Phillips & Associates, Inc. |
| Phillip Czosnyka, model and drawings |
| Private Residence, 1991 |
| Burr Ridge, Illinois |

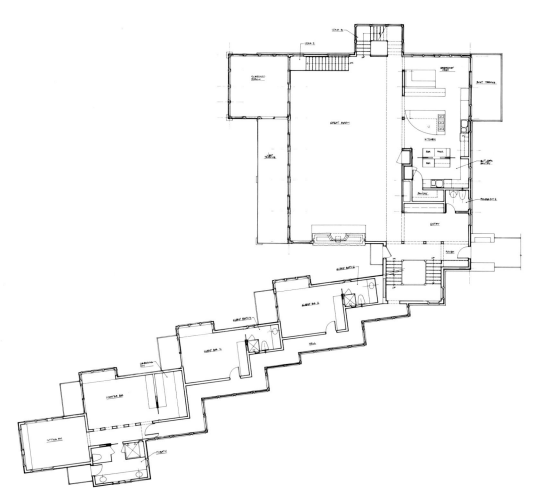

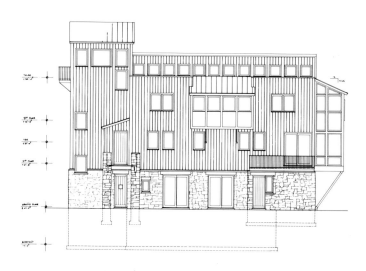

This Michigan vacation house is the physical manifestation of the mediation between the geophysical forces of the site and the program, with a predisposition to vernacular forms. Beyond orientation and natural vegetation, the geophysical forces included a Michigan Department of Natural Resources ordinance which dictates that in "critical dune" areas along the Lake Michigan shoreline, slopes greater than twenty-five percent cannot be impacted by construction. The boundaries of the floor plan are held in check by a relatively narrow throat between two steeply sloping dunes.

The approach to the house winds through forty-four acres of a forested dune formation arriving at an elevated parking terrace which nestles between the remains of an existing retaining wall and knoll. The entry bridge slides past the cubic volume of the house into the stair tower, on axis with the lap pool beyond. The cubic house form is transfigured in section at the juncture of the main living space and tower. The roof slopes up and away from the lake and the west sun inflection, enveloping the circulation spine of the children's third floor.

Completely glazed spaces push through and hang off of the building volume as at the north stair pushing out and above the critical dune slope below or at the children's playroom pushing out, celebrating a willfulness against order, the taught symmetry of the boys'/girls' dormitory.

The master-bedroom suite and guest bedrooms create a wing sitting atop wood piers. The wing splays and staggers back for views and private balconies, ending with the master-bedroom suite and its 180-degree exposure. This elevated position atop the forest of wood piers affords views over the crest of the adjacent hill and down to the ravine beyond as well as extending the exterior space at grade. A fully glazed circulation spine hangs off of the wing, avoiding impact with the dune below.

Kathryn Quinn

Vacation House, 1993

Covert Township, Michigan

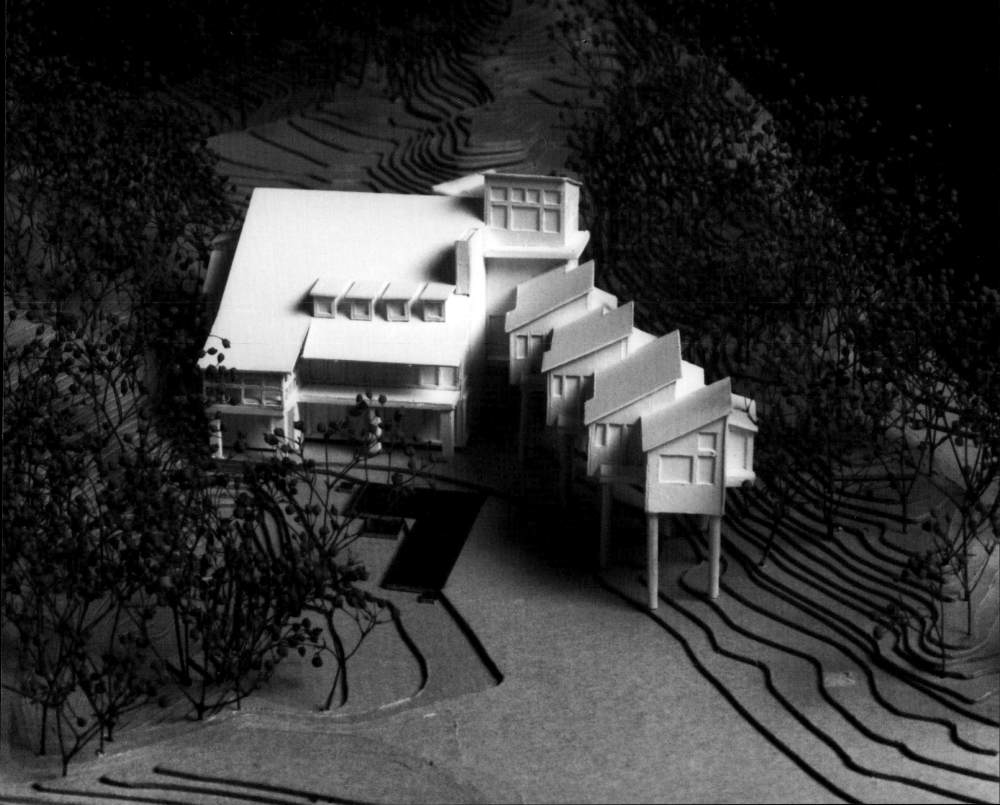

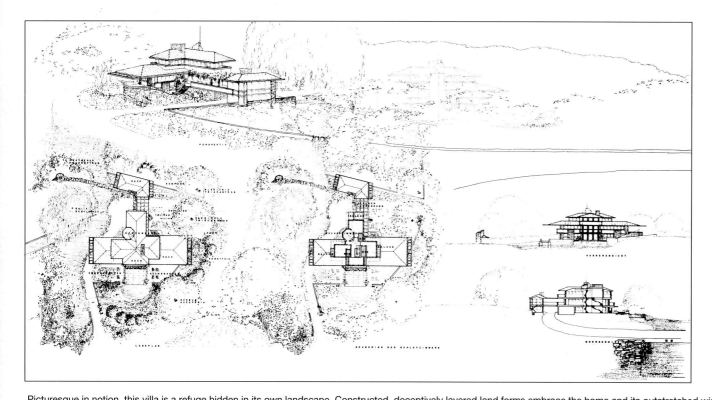

Picturesque in notion, this villa is a refuge hidden in its own landscape. Constructed, deceptively layered land forms embrace the home and its outstretched wings over and under the site. Earth, sky, and water thread themselves through the built-up suggestion of a mythic terrain. Repose is provided as space volumetrically interlocks with the cosmic power of nature. Solid is cantilevered over void, a dynamic simplicity.

Floating layers are built up for the villa, stretching towards a studio, bridging a lap pool, splashing through a conservatory, suspended to the anchoring folly. From water and land features, the crafting of a shelter merges visually with the dream site.

The style of the built objects is of basic structure, extended in cantilevers, floating in a compositional balance. As if from geological discovery, gentle forms hover out from each other. A placid center is at the hearth, anchoring the open layers to the forest floor. Natural materials for interiors and exteriors are as they might be found in an unspoiled state.

Not only a derivative concept, but an extension and interpretation of principle allows for a dream space of wonder.

Carefully seeking maturity as a natural form of the land, the tent of trees cover and shelter. Layers stretch and span, reach and radiate from a constructed suggestion of an interpreted landscaped form. The craft is in combining the function, feature, fantasy, and utopia of a garden paradise.

Christopher Rudolph
Villa Bauten und Garten, 1992
Burr Ridge, Illinois

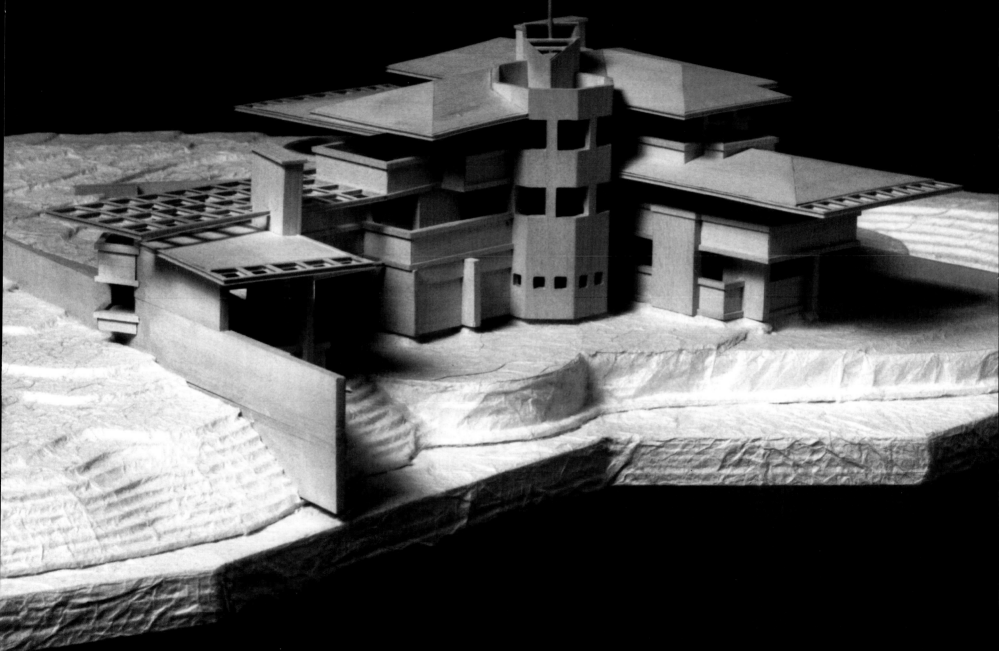

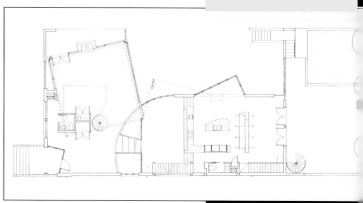

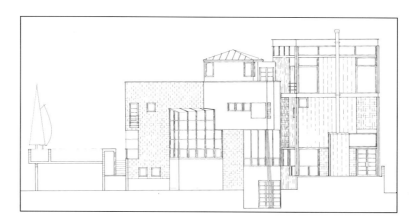

Ken Schroeder
Schroeder Murchie Laya Associates, Ltd.
Urban Courthouse, 1993
Chicago, Illinois

This new house, situated on a double lot, is conceived as two houses side by side in elevation. One house is a three-story limestone "bar" volume that is complementary to its adjacent turn-of-the-century neighbors. The second house is joined to this limestone volume but is made of gray steel and rotated to relief the elevation mass relative to the structure.

The house wraps around an outdoor space that faces south. The floor levels cascade upward to meet a terrace/garage roof that overlooks the courtyard space and serves as an informal recreation space.

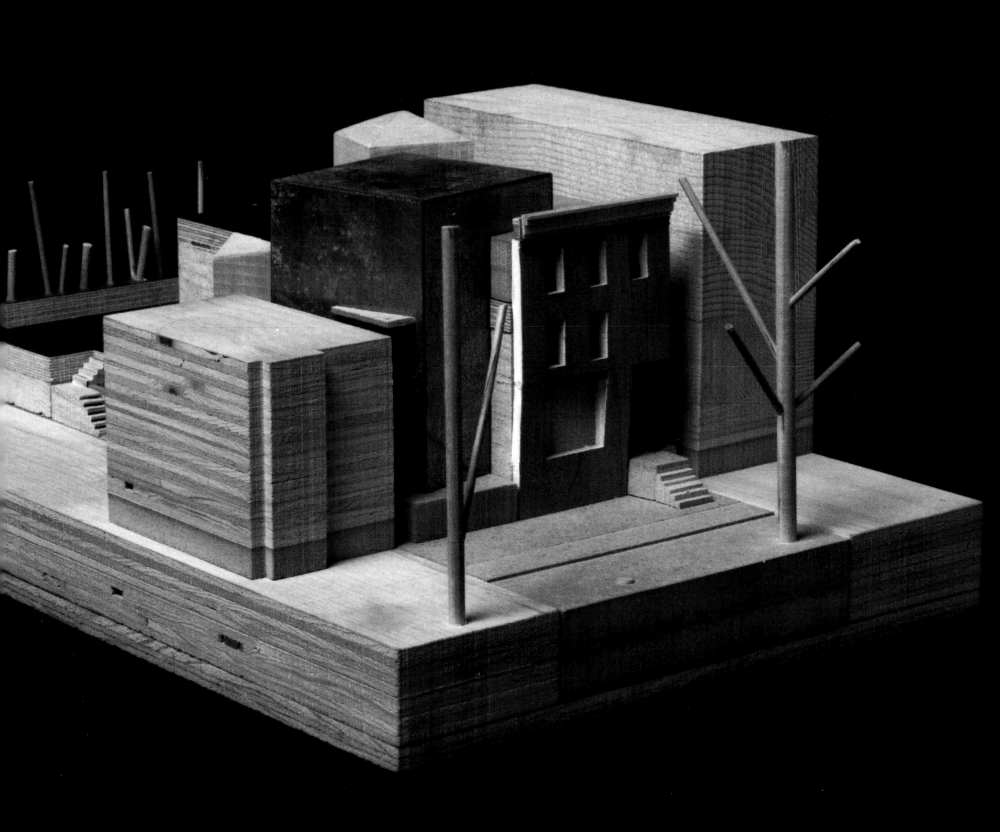

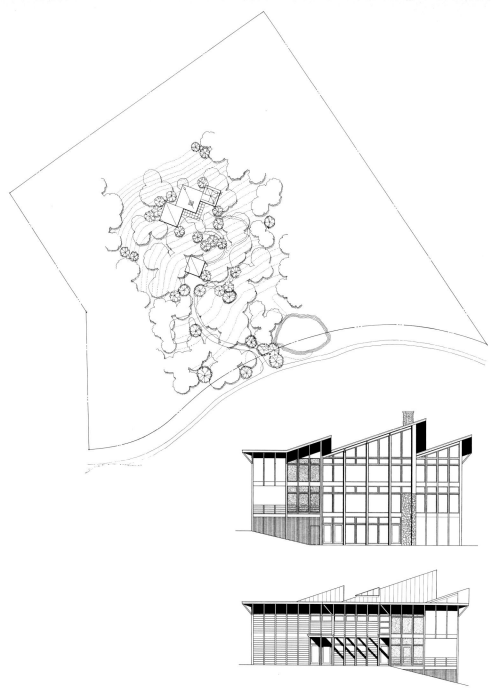

The house of mediation. **A house designed for a mediator and a theologian is concerned with the need for openness to the views and privacy of individuals and the family. Places for meditation and study are provided in a loft library above the living space and porches at all levels.**

This residence is sited on a ridge overlooking the Mississippi River on a sloping wooded site. The view looks directly north, allowing an infinite view of the river. The house is oriented to maximize the greatest number of surfaces to the views, therefore its diagonal orientation.

It is planned on a four-foot module. Three attached square areas are arranged with the central square containing the living spaces. Each side module supports the center. One side contains sleeping, the other contains porches and decks. The exterior is all glass on the river side, except for where a fireplace is located on the corner. On the entry side, horizontal siding wraps the exterior, interrupted by vertical trim boards that express the structural and window module of the house. A fourth square is located towards the road as the garage.

The roof is tilted up toward the views on all three squares, with an exposed ceiling inside each space below. The livi area contains a planter for bamboo trees at the apex of the room to provide greenery year round. The fireplace is located on the outside corner to allow simultaneous viewing.

| Linda Searl |
| Barker Residence, 1993 |
| Hanover, Illinois |
| |
| |

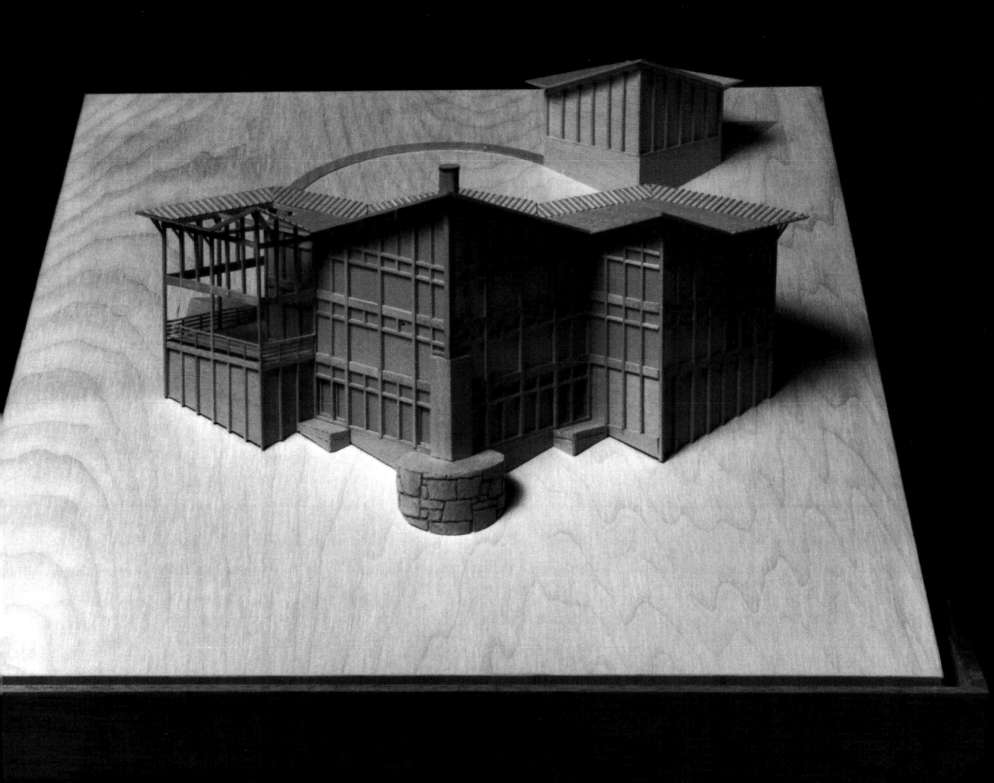

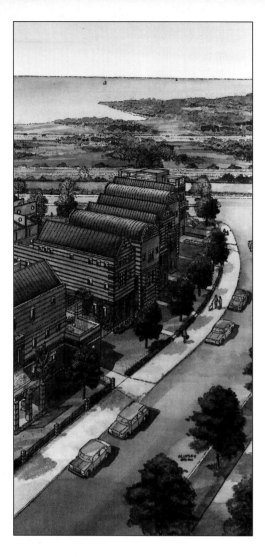

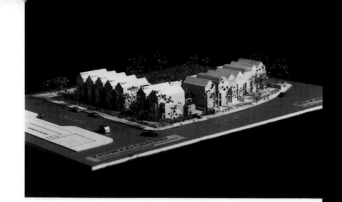

The home of Kenwood Gateway, the Hyde Park/Kenwood neighborhood, is also the home (or former home) of the University of Chicago, the World's Columbian Exposition of 1893, and the Frank Lloyd Wright Robie House, as well as being the beginning point for the urban-renewal program in Chicago. Often cited for its social diversity and intellectual achievements, Hyde Park/Kenwood is equally famous as the historical repository for every housing type built within the city since 1850.

This site was purchased from the city of Chicago with the following restrictions: that the program be a low-density residential development not exceeding fifteen units; that the residences be oriented away from Lake Park Avenue, and onto the two other streets; and that there be a minimum number of curb cuts for private drives. In its present form, Kenwood Gateway is composed of fourteen detached, three-story single-family houses placed along the Dorchester and East 48th Street edges of the site. Parking has been provided at the northeast corner of the site with a mixture of an open lot and ganged garages to form a courtyard. Those houses whose sites do not extend to this courtyard entry have been provided with attached garages. All houses are built of solid masonary

David Swan
Kenwood Gateway, 1986-94
Chicago, Illinois

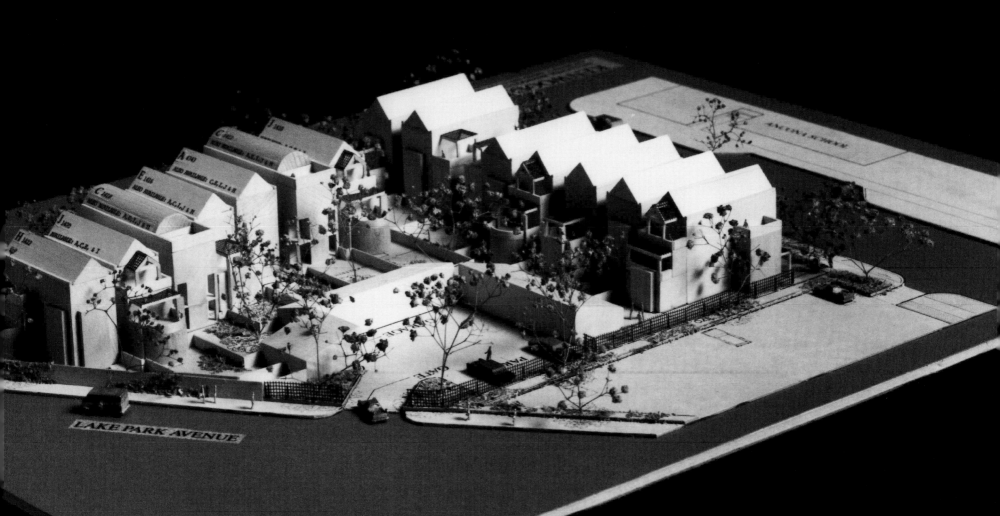

LAKE PARK AVENUE

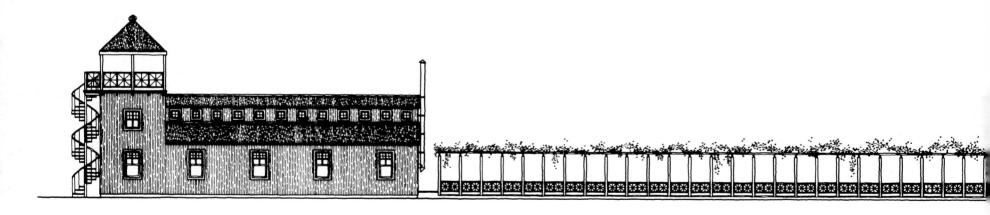

The project is designed for a former client for whom a house was designed in 1967. He owns property in southern Wisconsin, which he cultivates and farms. His produce includes Christmas trees in the winter and fruit in the summer. The farm will be administered by his daughter. The program includes a small house for her, another small house for him and his wife, a greenhouse, and a storage/sales building. Parking for customers driving in off of the road completes the functional requirements of this project.

The solution organizes the four buildings into two precincts, each of which is connected by treillage. The precinct at the leading edge of the property is denoted by sales and greenhouse buildings. The precinct at the rear of the property is denoted by the two residential accommodations, connected by treillage, and centered by a lap pool. Each of the four corners is marked by a tower. The concept is informed by marking rural and farm properties by stakes establishing territoriality. There is no intention here of expansion—thus, the "staking out" of the land is appropriate.

Each of the four buildings is twelve feet wide. The residential buildings face each other, with the lap pool (covered by treillage) equidistant from each one. Sales parking is at the road, equidistant from each of the two forward buildings: the sales building and the greenhouse. The Towers (the name of the project) at roadside are used by patrons to spot the area in which they will be "picking" their produce. The towers at the rear of the property are recreational and are also used to inform the owners if customers appear at roadside.

The construction is made of wood frame clad with corrugated aluminum siding. Wood windows, wood floors, and beaded board are all utilized in an attempt to build contextually in, and with, nature, as rural farm buildings have always managed to appear comfortable in nature.

| Stanley Tigerman |
| Tigerman McCurry |
| The Towers: A Truck Farm, 1989 |
| Southern Wisconsin |

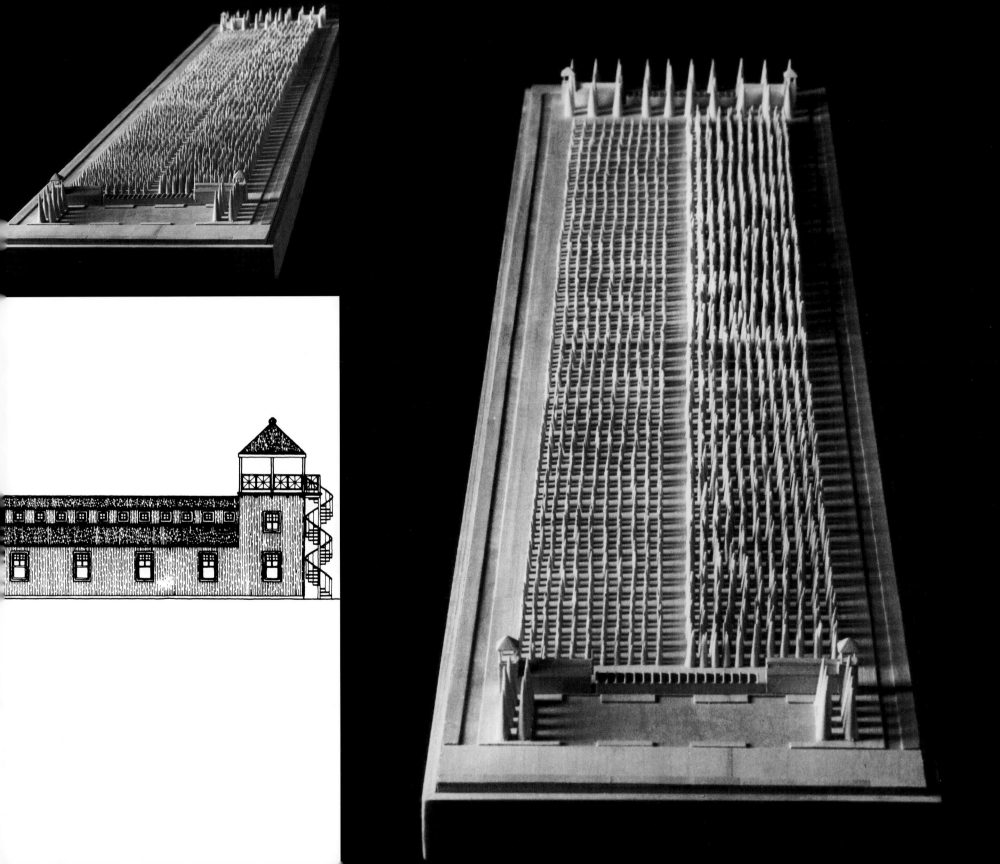

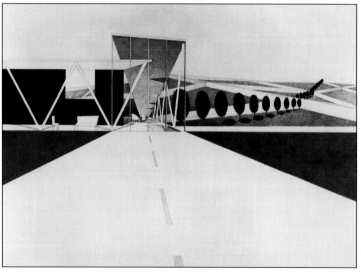

The Rooms

The rooms are in the city. They do not form houses, which do not form blocks, which do not form neighborhoods. The hierarchy of the traditional city is exchanged for a system of increasing entropy. There is space for individuals, but not communities. Rooms criss-cross the landscape extending to the horizon. They define a fabric where the difference between one place and another becomes blurred and ambiguous. Although each room is different, they are really the same.

The land is spared or at least excused. It is no longer the leftover, unseen space between inward-looking houses. Instead, the earth becomes a sanctuary which always has a presence in the surrounding rooms.

The Enigma

Once the land and culture conspired to make every place different; one town was different from another. The people who lived in a town felt rooted to the community, where everyone was the same. This is the way it was, or at least the way we think it was.

The shared experience of a community makes it possible to define the meaning of things. Modern people are individuals, no longer members of a community. They are rootless, the past is not shared with others, defining the meaning of things is impossible. Modernism makes everyone different making the meaning of every place ambiguous.

If the meaning of something is ambiguous, then it is also free from traditional understandings and interpretations—in a way, it is innocent. Modernism erases the language of culture, making things innocent of meaning. The rooms are enigmatic, their meaning is ambiguous, they reflect the innocence of the American culture, where the absence of history and tradition affords an individual a perfect naive freedom.

Joseph Valerio

Joseph Valerio, Randall Matheis and David Jennerjahn

The Enigma of the Rooms, 1993

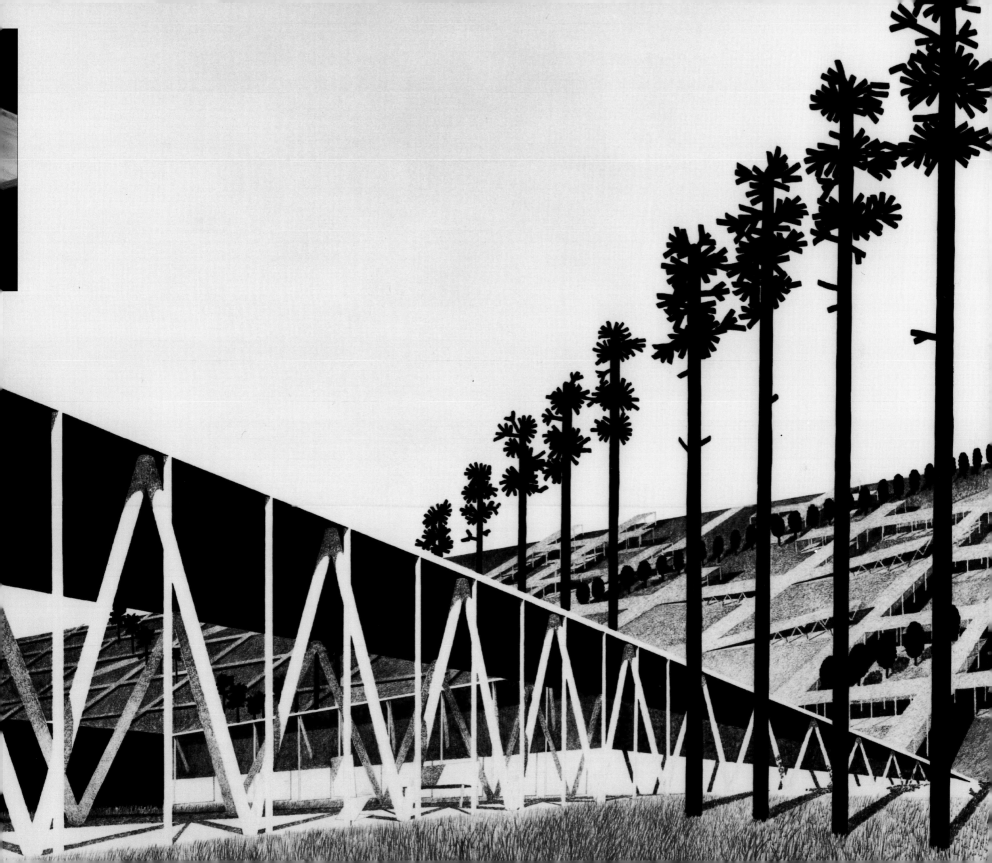

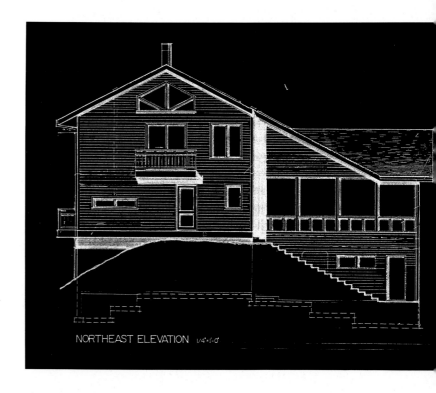

NORTHEAST ELEVATION 1/4"=1'-0"

Located in southwestern Michigan, the residence and studio is designed for large family gatherings and as a weekend retreat from Chicago. The site is a wooded series of sand dunes, adjacent to a forest preserve.

Integrating the various building elements into the site was the primary design premise. Floor levels and plan configuration accommodate a number of one-hundred-year-old oak trees, which provide a canopy of shade during the summer months.

The house contains two bedrooms in the lower level, which open on grade to the rear; a two-story living and dining space; and a loft master bedroom designed in the living/dining volume. A large screened-in porch is oriented to receive cooling Lake Michigan breezes in the summer. A sheltered walkway links the main house to the studio addition, which features a large studio and work room on the upper level, and a bedroom, library, and recreation space on the lower level.

Stained cedar siding was selected for the exterior to visually blend the building elements into the natural environment.

| Wilmont Vickrey |
| VOA Associates, Inc. |
| Vickrey Residence and Studio, 1993 |
| Bridgman, Michigan |

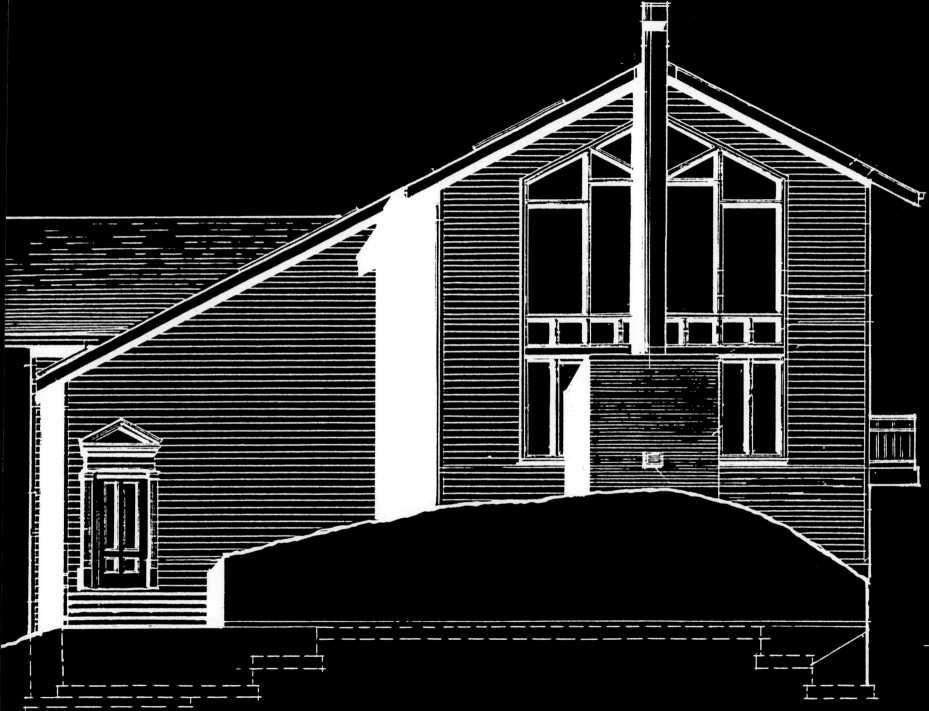

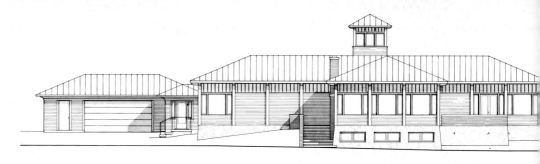

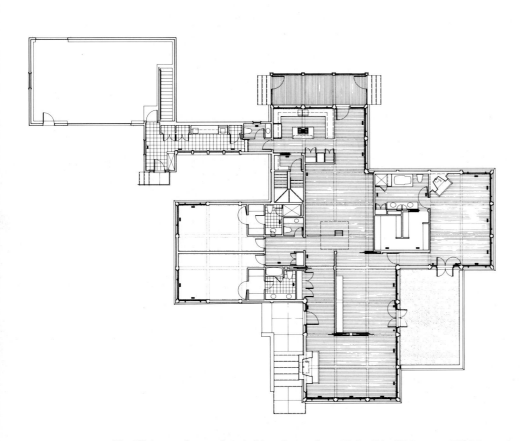

The Wetsman house, located two hours from Detroit in Metamora, Michigan, is situated on former farmland. The site includes dense forest to the north and east, with a man-made lake placed at the southwest corner of the forty-acre property. The house is constructed of wood posts and truss-joists, with rigid steel reinforcement to compensate for the wind loads and allow for open fenestration. The plan of the house is a symmetrical pinwheel design on a nine-foot plan module. The void created by the intersection of the four arms serves as a lookout and allows daylight to enter the central hall and dining area. Each window frame, with casements and/or transom panels above, fits within the post structure; side casements allow for natural ventilation. The mahogany windows are recessed between the exterior framed columns, with horizontal cedar siding below them. The plan allows for optimum exposure to views offered in all directions. Connected to the house is a three-car garage and passageway, which allows the client to enter the garage from the house.

Though the plan suggests Wright's cruciform plan for Prairie houses, the Wetsman house differs in several repects. In his prototypical plans, Wright used the fireplace to generate the pinwheel, shifting the axes to conform to the plan, and varying the width and depth of the corresponding rooms. The Wetsman house, on the other hand, depends on the rigorous symmetry of the plan and its adherence to the nine-foot module. The open public areas can be divided by sliding doors with translucent glass lights for privacy. Contrary to Wrightian horizontality, the exterior of the Wetsman house, with its projecting columns, suggests a classical villa as well as a crafted house of the twentieth century.

John Vinci
Office of John Vinci, Inc.
Wetsman Residence, 1994
Metamora, Michigan

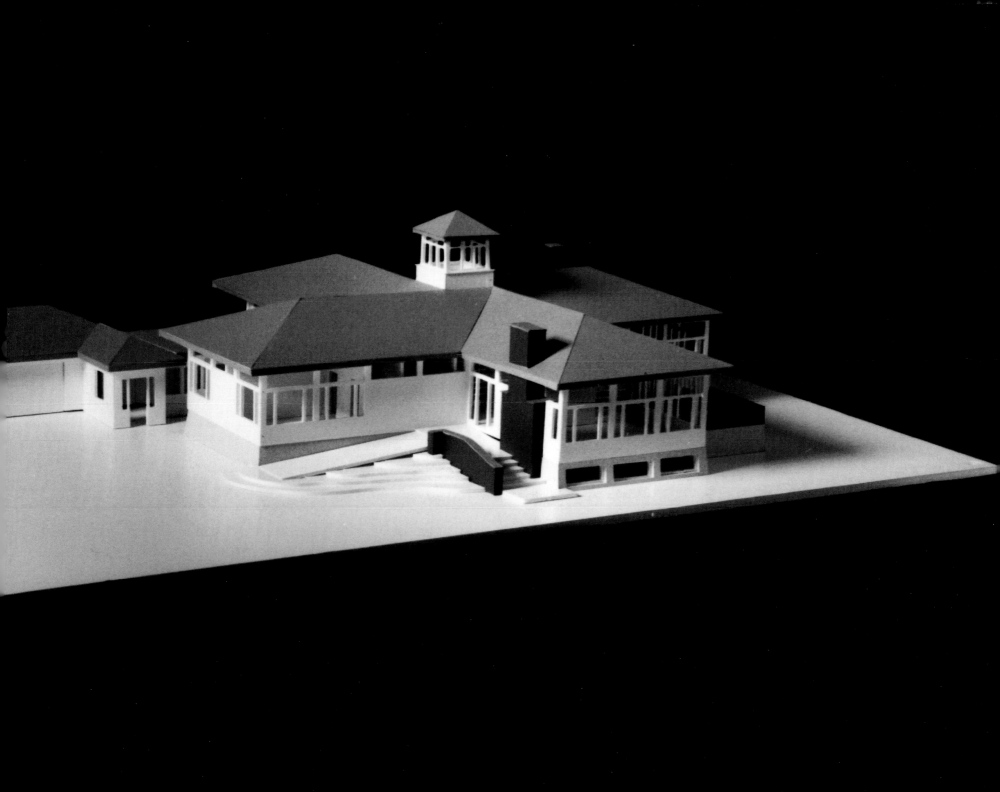

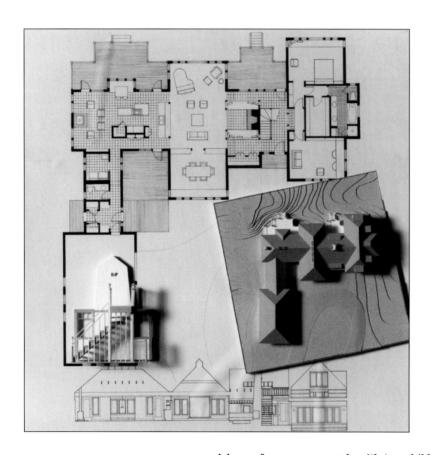

A house for a young couple with two children. The site is a gentle dune covered with white pine and birch forest on the western shore of Lake Michigan. The family asked for light-filled open spaces strongly oriented towards views of the lake. Entry is from an informal court on the west side of the house, into a gallery which penetrates through the house to a deck facing the lake. The gallery also contains a stair to the second floor backed up by a fireplace and an inglenook. To the south of the gallery is the two-story bedroom wing; to the north are the communal spaces. The living/dining room is at a cross axis to the line of the plan; it is lit from a ridge skylight above. The kitchen and family rooms extend to the north and are also lit from above. These rooms are all open to each other, yet are defined by low partitions and separate roof volumes. Continuous wood trim encloses the spaces at door-top height and crosses openings to define spaces. Within the asymmetry of plan and elevation are careful and tight symmetries of location and detail.

Cynthia Weese
Weese Langley Weese Architects, Ltd.
A House in the Woods, 1983-84
Sheboygan, Wisconsin

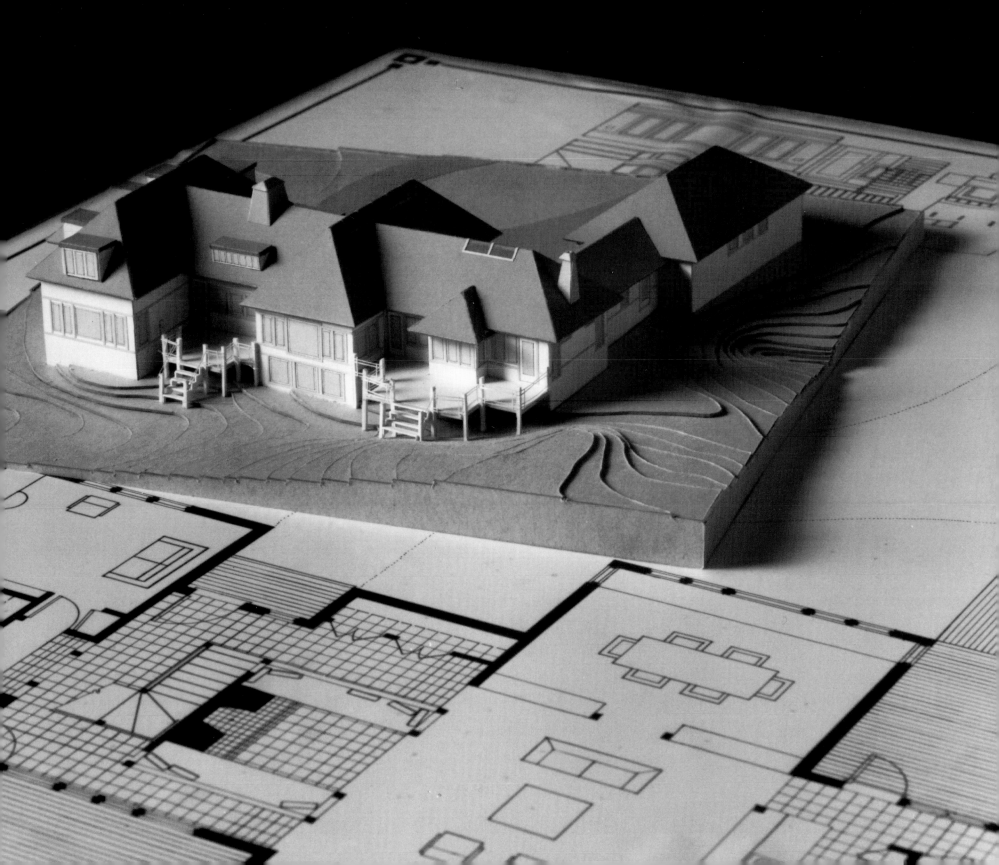

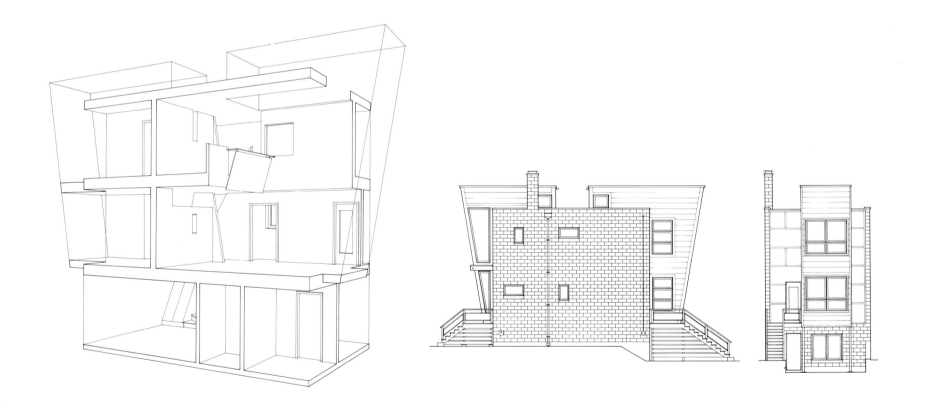

The house at 2444 North Talman tests the economics of new construction for the first-time home owner. The house equates economy with size, simplicity and material selection. The architectural objective is to make the largest possible living spaces within the smallest possible frame. The use of natural light and color directly challenges the urban condition.

The house is intentionally small. Its footprint of 20 feet by 30 feet occupies less than twenty percent of the 25-by-125 foot site. The limited house size allows for the large private garden of 25 by 55 feet. The form of the house expands beyond its rectilinear structure. Two projecting bays provide clerestories of west light to the living room and east light to the bedroom. In these rooms, the windows on all four faces provide an unlikely urban setting.

The living spaces of the house are open and lucid. The two-story living room stretches to the balcony above and the kitchen beyond. The bedroom has a view to the east through the balcony, above to the sky and below to the garden. Each room contains the remainder of the house.

The materials and colors divert the simplicity of the form. The bearing walls are unfinished concrete block. The rough gray masonry affords a neutral field for the wide use of color. Materials that expect to be covered are untouched and those that should be bare are saturated. The oak floor is stained blue, the cabinets are clear-coated particle board and tangerine-colored laminate, and the counter-tops are red Dakota granite. No fewer than ten colors are used to deny this small house its simplicity and urbanity.

Catherine Wetzel and Nabil Zahrah

ZED Architects

An Urban Speed Bump, 1991

Chicago, Illinois

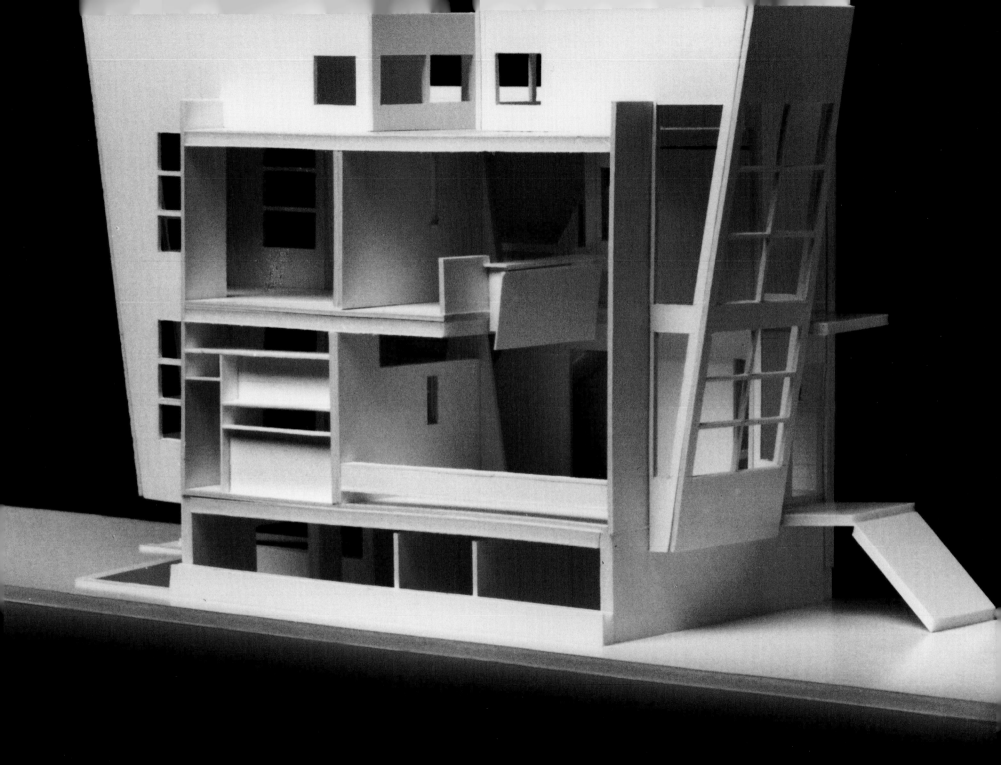

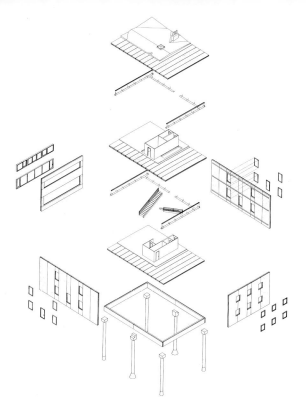

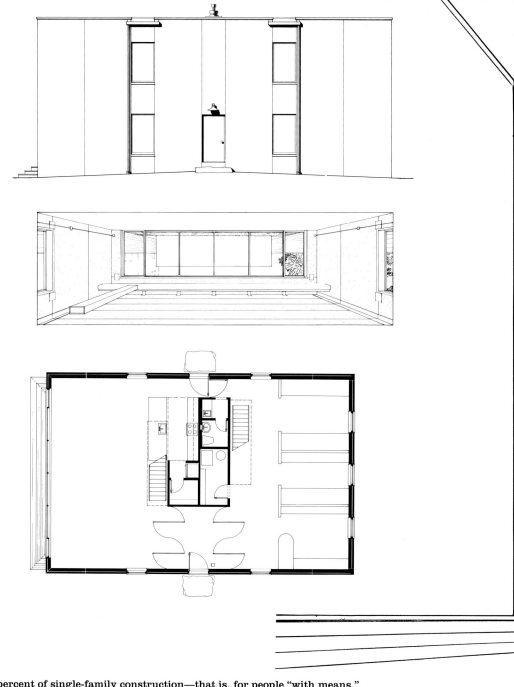

Daniel Wheeler
Wheeler Kearns Architects
Live/Work Structure, 1993-94
Chicago, Illinois

Statement: Architects have been and will continue to be involved actively in five to ten percent of single-family construction—that is, for people "with means."

Statement: Architects have been and should continue to be a form of research and development for the housing industry—that is, for people "with less means."

Constraints of budget, fire resistance, and existing substructures dictated a preengineered and prefabricated solution for a new breed of house — live/work — on an urban site. This is a house for two graphic designers, their family, and their place of business. Atop six site-cast caissons, insulated precast concrete grade beams, wall panels, and floor slabs are erected within the span of two days. Interior build-out is commercial in spirit; electrical services delivered within the tinted, polished concrete topping; exposed mechanical ducting serving as supports for indirect lighting. Exposed concrete walls and ceilings are lightly sandblasted, contrasting with the oiled medium-density fiberboard doors and trim. The "work" area addresses the commercial street, while the "live" area opens onto a sheltered garden.

The structure poses questions as to the "accepted" methods and expectations of "house" construction. Labor savings from minimal excavation, speed of erection, and the localization of on-site interior finishing result in a structure of breadth and permanence that would be otherwise unattainable, at a cost two-thirds to one-half less than that of conventional construction.

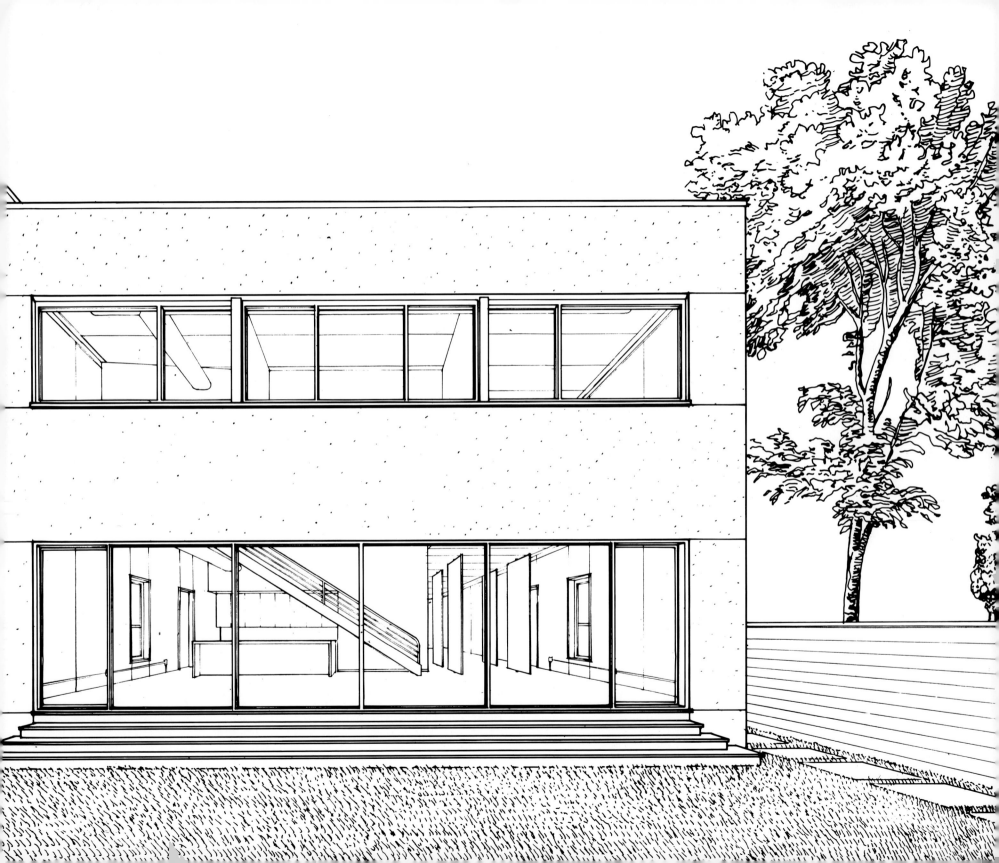

**The Renaissance Society at
The University of Chicago**

Credits

ISBN 0-941548-29-5
The Renaissance Society at the
University of Chicago

©1994
The Renaissance Society at the
University of Chicago

Designed by
JNL Graphic Design, Chicago

Edited by
Jean Fulton and
Joseph Scanlan

Photography by
Tom van Eynde

Printed in an edition of 1000 on 80# Mead
Moistrite Matte and 80# French Speckletone
by the John S. Swift Company, Buffalo Grove,
Illinois. The catalogue was typeset by the
designers using Adobe Helvetica and Adobe
Clarendon in Quark Express 3.3.